D1649122

Calm Things

essays

Calm Things

essays

Shawna Lemay

Palimpsest Press
96 Stewart St, Kingsville, Ontario, Canada N9Y 1X4
www.palimpsestpress.ca

Typeset in Adobe Garamond Pro
Book design: Dawn Kresan
Printed and bound in Canada

Library and Archives Canada Cataloguing in Publication

Lemay, Shawna, 1966-
Calm things / by Shawna Lemay.

ISBN 978-0-9784917-3-4

1. Still-life in literature. 2. Still-life in art.

I. Title.

PS8573.E5358C35 2008
C814'.54 C2008-903003-6

We acknowledge the support of the Canada Council for the Arts
for our publishing program.

Canada Council Conseil des Arts
for the Arts du Canada

Table of Contents

7 The Dreaming Side of Life: Living with Still Life

17 Still, Dead, Silent

27 Precarious

37 Calm Things

45 To Lost Vessels

55 The First Bouquet

67 Of Coffee Pots, Teacups, Asparagus and the Like

75 Spring, Again

82 Acknowledgements

84 Books Consulted

85 About the Author

for Rob and Chloe

The Dreaming Side of Life: Living with Still Life

I dream that I will write this twice, at least twice, though in the end it may remain with the dreaming side of life. I should say that it is something I have attempted before and discarded. I cling to it, as one, helpless, clings to bright failure, forgetting, as one forgets a recurring dream. When the dream returns it swells into the present and one feels like a fragile vessel on the edge of a table trying to hold the light that pierces, intermittent, through a window on a cloudy day. The essence of the dream leaves the body in a rush and then the mind discards it.

But dreams cannot be discarded. They well up, they pool, they repeat. Some believe that in death our dreams and our lives are remembered on the same level of existence.

I'm interested in the banal — I don't want to miss out on any crumb of existence. I'm interested in the act of forgetting and also in whatever repeats. In this house, we are attuned to the secret currents of the mundane, to the cracks in things. We lean toward those invisible leakages of time, fissures leading to infinity.

7

To connect through ages, to collapse time, these are our rather lofty goals, my husband's and mine. The past abandons itself to the present — they collide at all times with a mysterious force — an energy that wants attending. Rob has just finished a painting of lilacs and pears and it rests on the sideboard in the living room next to a water glass of garden flowers. What a conversation the living must be having with the dead!

In the late evening, when the sun is just going down and the painting glows with its own inner light, one feels also the presence, or hum, of their conversation. Odysseus Elytis, the Greek poet, wrote that "We don't eavesdrop enough on the secret conversations among things." So many secrets, ours for the taking. It seems Manet is there too. Dying, he painted the vases of flowers that people brought to his room, lilacs among them. Kafka, on his deathbed wrote on slips of paper, things like, "I'd like to take care of the peonies because they are so fragile." "Move the lilacs into the sun." "See the lilacs? Fresh as morning."

*

When I am speaking to someone I've just met who has learned that I am a poet and my husband a painter of still lifes, they often tell of an object they possess that possesses them, or a flower to which they have a deep affinity. The person's eyes will often fill with a thin film of water. What a tremendous gift, these moments — the quiddity of the object truly felt. Spoken, the secret connections a person has with an object become electric. There is an energy in the air surrounding the words and my hair bristles at the scalp and my scalp tingles. I've had this feeling also when a friend writes in an email what their dinner is to be. Such simple statements that send me hurtling through time and space, to I know not where. "I'm preparing leek and potato soup tonight" or it's an old slow recipe for chilli. Or nothing but popcorn.

The tingling reminds me of those instances I have often heard described, when one comes face to face with a great work of

8

art. A work of art to which one has that instant heart-stopping, pulse-racing reaction. One of my favourite descriptions of this sort is in *Little Saint*, such a quiet and tender book full of love, by Hannah Green. Before a gold and jewel encrusted reliquary in the village of Conques in France, she says, "In that stilled moment, awed and torn with tenderness, the top gone from my head, I saw not only her, Sainte Foy, but shadowy figures around her." When I want to be in the presence of a calm and undeniable joy I pick up this book and read a passage or two.

Shortly after I met Rob he had a show and I went to see it by myself, on a day other than the opening. I had the gallery to myself after a brief, encouraging smile and hello from the woman at the front desk, whom I since have come to know and consider a friend. I was full of trepidation. What if I disliked his work?

But, no. I had that feeling, as I whirled around the gallery, getting close to see the brushstrokes, and then moving as far back from them as was possible. I knew, for the first time, that sensation, the top gone from my head. It was all a fantastic revelation — the paintings, the sensation, falling in love. It's a moment that I recall more in the way that you remember a dream — it dances just out of my reach — I can almost taste it — joy.

At a show this spring, I spoke to a woman with a lovely smile who bought a painting of white lilies tinged with pink in three transparent vases. A paediatrician working with high needs cases, she facetiously said that the painting was worth three months of Prozac. She planned to meditate before it and to do yoga in the same room as the painting would hang. It would be the centre piece of her house, which already housed many well-known artists. What she treasured in this particular painting, she said, was the light. The light which steals into this painting and makes it radiant. She spoke about when she first encountered the painting at the show, and though she didn't exactly say, I suspect she had that feeling — the top gone from her head.

*

A few nights ago I finished reading Umberto Eco's *The Name of the Rose*. I read it a couple of chapters at a time, partly because it made me very sleepy after the long and busy days of being with a small child, and partly because it's a wonderful luxury to read a book slowly, savouring it. The copy we have is one that Rob bought in Portugal years before we met. It has the feeling of having traveled, this copy which I love, because books are a way of traveling. And while a book like this is a great companion before bed as it contains so many thoughts that after a couple of chapters the brain voluntarily shuts down — it also contains many moments that jolt you awake. One moment, a line that I underlined — "No one ever obliges us to know…We must, that is all, even if we comprehend imperfectly."

*

I made it my task for a year, 52 weeks, 52 poems, to attend to the dailiness of things, paying attention to the ways things intertwine — I wrote about things — particularly things that would appear in a still life. I wrote at the end of the book that came of this year, "These poems were written as an exercise toward perfection through the opposite of perfection." I did, in the end, comprehend imperfectly. But after a book that one has written is closed and one begins again, it is all forgotten. Lost and bewildered, one must begin again. As Samuel Beckett said, "Try again. Fail again. Fail better."

Each week I failed again. Try, I told myself. At the beginning of the week I chose an object to study, to meditate on, to obsess about. For a week I lived with thoughts of an apple, a hydrangea, a plaster cupid, rattling around in my head. I tied myself to this object. Sometimes it was just the word, repeating, a chant to a pear or a plum. One to the table. At the end of the week, in the house alone, I told myself to try. I wrote a poem — the method was something I likened to the studio exercises of artists, student painters. What I wanted to find in my writing was a sort of freedom, and this is what I did find. The poems won't likely

go down in history but they took me to another place in my writing. Closer toward where I want to be as a writer.

I would sometimes read an entire book on the subject of my weekly meditation. I would try to find a few paintings containing the same. Always in my thoughts were paintings of Rob's. Paintings long since sold would float around in my mind. Often I would choose my subject from his most recent painting which always rests on the sideboard in the living room.

My room, and sometimes my dreams, would become littered with bruised fruit, flower petals, art books splayed open on the floor — a Cezanne, a Fantin-Latour, a Claudio Bravo, a Paula Modersohn-Becker. I tried to capture something of the object at hand with as few brushstrokes as possible. I wanted to know that particular thing, however imperfectly. I wanted to know it as one knows one's dreams — that tenderly.

Guy Davenport has said that "still life persists for four thousand years, and deserves study for that alone." I found myself thinking about the frescos in Pompeii quite often. How beautiful the bowls of fruit, how still and quiet the paintings of game. The more I looked at, say, my apple, and all the images of apples recurring through time, the more I felt they knew each other — as if they'd appeared in one another's dreams — and in turn, it really did seem as if they knew me. I felt known, somehow, inexplicably, through these encounters, through this very simple process, this coming to an object, open. I had made a connection to all those who had been in the presence of an apple, and attended to its apple-ness.

The process did truly became more important than the poem. I wanted to come to the thing with a proper purity, clean. I sought to transcribe the dreams of the thing. Jane Hirshfield says in her excellent book on poetry, *Nine Gates*, "that an awareness resides in the things we wish to observe and know, and that the way we come to them matters." I came to love these things, their

11

dreams, all the apparitions that surround them. Rilke says, "In order for a Thing to speak to you, you must regard it for a certain time as the only one that exists, as the one and only phenomenon which, through your laborious and exclusive love, is now placed at the center of the universe, and which in that incomparable place, is on that day attended by angels."

Did I mention that in my room, with all the wilting flowers, spoons, vases, slowly rotting fruit, there were also angels?

*

Standing in front of Willem Kalf's painting of a lobster in the National Gallery in London I once experienced Stendhal's Syndrome, which is when one feels faint, physically overwhelmed, overwrought with rapture, in the presence of so much beauty. Not being able to afford regular trips to great museums, I have learned that it is possible to become overwhelmed by an apple.

*

Most days we rise at 6am to have an hour or two in the magnificent morning quiet and while our five year old daughter is yet asleep. I go to my room and sit, as I am now, at the computer, or on other days I sit in the red velvet chair and read and jot down a word, a sentence. I stare out the window. I look at the sandals I, radiant, wore on our five week honeymoon in Italy that I have hung, one each, on the two knobs of the closet door. This was at first just a way of getting them off the floor, but whenever anyone comes in the room they smile at this odd bit of decoration, and I'm fond of them as well, so they stay. The story that goes along with the sandals is that when we were on the island of Sardinia staying at a friend's villa, we walked every day down the long and hot, paved road into the town, Monte Petrosa. (The town was essentially a grocery store and café). Walking back one particularly hot day, our arms laden with groceries and bottles of wine, my sandal broke. There wasn't any question of hitching a ride, as no cars had passed us the entire time. Rob noticed I was wearing a hair pin and used

12

it to fasten the strap quite securely. In the winter when I look at these sandals they seem to radiate heat, yet, from that road with rocks of every shape and size alongside. I'm transported. Other objects transport me as well. I have lined several up on my windowsill. Mostly they are things given me by friends and come from near and far. A rock from my childhood collected one spring from the fast flowing edge of the North Saskatchewan river. A carved ebony horse head, sad, ferocious, noble, from Gabon. A stalk of glass wheat given to me for doing a reading at St. Peter's College outside of Saskatoon. A thin, elegant bottle of ouzo, the glass the colour of honeycomb, from a friend's vacation in Greece. A poem another friend wrote for me, about me, tucked into a card of an Amazon in battle.

My silver pomegranate is there too, which has appeared in poems, and in a painting Rob did many years ago now. It sits there as if it knows of its minor yet glorious exploits, brief moments of fame. It stands out a little from the rest as though to say, see how lovely I am, and esteemed.

Rob has taken his coffee and gone down to the corner of the basement which is near the window at the front of the house. Outside, the mock oranges are in bloom. By now, he has unveiled the paint mixed up on the big pieces of broken glass beside his easel. He has just begun painting a deep purple-red peony. Yesterday he painted a few petals, and today he will resume. He will have eyes only for the myriad smears of paint, all the gradations of red, blue, purple, and for the small area, maybe two inches square, that he's working on. The canvas is full of delicate-thin pencil marks, a tracery, which are beautiful in their own right — two days of drawing to be gloriously hidden.

By now I'm nearly, sadly so, unaffected by seeing him paint. But I do remember the first time he let me into his studio. I watched as he dipped his sable hair brush and dabbed the canvas, mixing that colour and this, then the magic of seeing that small area of canvas become a realm.

I remember feeling skinned, stripped down, watching. The motions of painting are visibly vulnerable. It was as though I'd been let into a secret chamber, where one could see the mind at work. It was sorcery, magic wand, potions, and all.

At the end, there was a cat. I looked up, at last, to see the mottled cat on the shelf with all the dusty vases, student sculptures and chalky old books. The cat was all eyes — it watched the movement of the brush as though it were a mouse, something alive.

I've since seen the mesmerizing film of Pollock dripping paint from a stick onto Plexiglas which seems to me the same sort of thing with broader strokes. The forgotten gestures of dreams.

*

Still life has aptly been described as being "outside narrative." I'm drawn to whatever resides on the fringes of things, the stories and dreams, the apparitions and angels that float around them. I don't mind at all living outside narrative.

I love to sit and read in the incomparable quiet of the early morning. I feel rich, I feel as though I am accompanied.

I read a poem from one book and then another. I often come back to the same poems — until I am become radiant with them. Their authors are what the literary critic, Carolyn Heilbrun, has called, "un-met friends." Alone, briefly, each morning, alone with their words, so clear and full of all the longing I too feel, all the despair and loneliness and joy — I know myself to be accompanied. "Only connect…." goes the epigraph to Forester's *Howard's End*, and however estranged from the narrative of the world, I experience connections.

Whenever I read this one poem, "Surely You Remember" by Dahlia Ravikovitch, I am visited, whatever darkness and shadows, whatever streaming band of light that comes with the day.

Sometimes it comes with tears, sometimes that joy so overwhelming you can scarcely say it.

> *You sit alone*
> *your heart aches, but*
> *it won't break.*

And then:

> *Narcissus was so much in love with himself.*
> *Only a fool doesn't understand*
> *he loved the river, too.*

I sit alone and my heart never yet breaks. How rich I am, me in my room, in this treasury of dreams and things. I fall in love with myself, dream myself, all the while listening, craning, attending, falling in love with the world plum by plum, apple by apple.

Still, Dead, Silent

Our daughter noticed first. The bee that came in a wavering, looping path through the front door and up the stairs, into the stifling room, and then at last, to the lilacs. She had pointed out the bee to me when it came into the gallery and kept her finger on it until it reached the painting, the lilacs. Then she laughed as it bumbled around the deep purple. The fat thing would back up to take another run at the uncooperative flowers, hit the canvas, and bounce back, then hum around again for a bit, before trying a different angle. This went on long enough so that our daughter managed to drag a few adults away to come and see. She dragged them from their wine and conversations, their hands mysteriously flapping and floating, arcing and diving.

When Rob came to see, we both looked at each other and said, Zeuxis! as if it were a secret password. Zeuxis, as every student of art history learns, was the revered realist painter of antiquity. Birds flew down to eat the grapes from his painted vine. My heart was caught high and folded up in my throat. The bee must be a good omen of some sort. It was a mysterious moment, touching

17

and silly, and then the winged creature managed to fly straight out the door, leaving us to wonder if it had all been a vision. I wanted to drench the moment in meaning, but then, no, I just let it drop. I, too, took a perspiring glass of cold wine and sipped, and let my hands move toward whatever I was speaking about, joining in creating the invisible knot-work of gestures that afternoon.

It was a lovely day, this day of the bee who fell in love with my husband's lilacs, which is what Chloe said to draw the small crowd toward her — look, the bee is in love with my dad's painting. All but a couple of the paintings had sold. Which, in fact, meant everything. A return to the calm that comes when bills are paid, and doubt has been sent its creeping way once again, as it always is, and always needs to be. A return to the table that sits in the middle of our small family and fills with odd objects, bowls of apples and nectarines, jars of lilacs, dahlias, delphinium, whatever is in season. The pleasing muddle of all this — the holy sojourn of light soaking these common things, casting shadows, some stark and deep, others mutilated and wild.

*

After a show, we all return to the proper rhythm of days, which has somehow left us in the weeks and months before. The paintings are a way of marking time, usually two paintings to a month, not quite two. And then I fit my poetry into that scrim of time and all is well. At lunch, Rob comes up from his studio in the basement, and we eat bread and cheese and pears cut up and talk about what he's been working on for the past several hours.

He works from photographs taken at elaborate, long, mind-bending sessions. The table he sets up near the window, under skylights, on a sunny day. It's the scene of a great battle and he is the weak god, the momentary god presiding over. To set up a vase of flowers, a couple of nectarines and a bowl of cherries in front of a white drape takes great force and energy. Hundreds of infinitesimal adjustments, the heat of the sun beating down, flower

petals dropping. Every leaf must be arranged so the sun strikes it a certain way. A cloud floats in from nowhere. He waits. These sessions are a workout. He moves into and back from the tableau, adjusting and adjusting, holding the camera perfectly still while the clouds scud by. He's breathing hard. Afterwards, his muscles are sore and he drinks glass after glass of water.

I ignore him completely while he takes his photos. I walk by occasionally and set down a book, or an object from my study. Chloe and I pick a worm-eaten apple from the tree outside and roll it across the floor toward him nonchalantly. Who knows what the table may accommodate or what astonishing balance may be struck with that one extra object?

*

Still life has mostly been thought of as the minor genre. Norman Bryson, author of *Looking at the Overlooked*, has noted that still life is outside of narrative. Still life exists in a reign of silence and it exists in the shadows of language. The term still life did not come into being until 1650. The French adopted the term nature morte, dead nature, around 1750. The painter de Chirico was said to have preferred the Italian term vita silente, and this is my favourite, too. Still, dead, silent, any will do.

Every now and then, Rob is pulled by the themes of Vanitas, the transience of time, memento mori. He ordered a replica human skull from a company called "Skulls Unlimited," and this has figured prominently in a few paintings. One is on a forty by sixty inch canvas with old books, seashells, and a pewter dish of plums before swaths of black and white drapery. Another is a close up of the skull sitting on a cloth the colour of fresh blood. Quite a few years ago, he painted an antelope skull and a housecat skull borrowed from a biologist friend. The skulls are part of a baroque composition that also includes strawberries, sunflowers, cut-open pomegranates, a narrow Persian carpet that seems like a dragon's tail, and various pewter vessels. I know these paintings quite well,

19

because I also live with them. They are among the (thankfully) few paintings that have not sold, the taste for Vanitas paintings not being what it once was.

<p style="text-align:center">*</p>

What makes some objects work together, balance, and some not? I'm yet surprised, after ten years of marriage, more than ten years of living with still life, of what will go, and also how it all connects. That you can take all these elements — the withered orange, the cracked vase, the pollen-dripping lilies, and you can make something of them. The meanings are various, personal, historical, symbolic. But the goal is to create a world, a window, a threshold. The goal is to get at something real, pared down, honest, to make a connection, a place in which souls can meet. To make something honest, I have learned, create an illusion.

<p style="text-align:center">*</p>

When I look at fruit at the grocery store, I'm looking for the imperfect. Imperfections make a thing seem more real. It's more interesting to paint an apple that is asymmetrical with an odd stem, a dried-out leaf attached. Sometimes we forget to eat the fruit arranged just so in the white ceramic bowl. This is true particularly with pears. It's a drama to which we're riveted. They slowly turn a soft speckled yellow. And then the exciting part — the sudden, unpredictable spots of brown. So ripe, they're easily bruised. Bits of skin inevitably rub off. Juice oozes microscopically from the wounds. By the time we're done looking, the pears are no longer fit to eat.

Cezanne's apples became a motif, and maybe for Rob it will be pears. Too soon to tell, I suppose, what a life's obsessions will be revealed as. Cezanne said, I want to astonish Paris with an apple! We go on being astonished. When I pick through apples at Safeway, I talk to them, say, *Astonish me*.

<p style="text-align:center">20</p>

I am often astonished at the grocery store, especially in the winter. The rows of quartered watermelons naked without their black seeds, the strange and haunting perfection. Where does it all come from? The fluorescent light shines weakly on the Chilean grapes. The polished star fruit sit gamely in a small perplexed tower. Before Christmas I picked out a few dragon fruit. None of the cashiers could figure out a stock number for them. I had no idea what they were, but I paid five dollars each for them. When I got home, I looked them up on the internet. We didn't want to cut into the red skin, into the red flower-shape until we knew what we would find. Inside, the flesh is white and it is flecked with black seeds, something like poppy seed cake. The rows of papayas, I notice on another trip, are sliced in half and wrapped in cellophane so that potential buyers can see the impossibly deep orange flesh, the long pocket of black seeds, the size of peppercorns. What colours would you mix to even get that particular orange I ask Rob. Yellow ochre, cadmium yellow deep, burnt umber, titanium white.

*

When the computer repairman came a few weeks ago, he was astounded that I didn't have a high speed connection. Nor do we have cable or a satellite dish. Nor do we have a TV that is as large as a painting. We don't have call waiting or Sega Genesis or a food processor. The poor young man's jaw truly dropped. I'd never seen anyone's jaw drop so realistically. I left him in my study for terrifying allotments of time. Terrifying because he was charging by the half hour. If I'd had high speed, it wouldn't have taken so long. Once when I came back, he was raving about the small painting of plums and nectarines that hangs to the right of my desk. The next time, he was entranced by the round oil sketch of a gazing or mirror ball that Rob had done of the living room of the last house we lived in by Mill Creek. It's disconcerting to me, this painting, because it's mostly the same furniture that we still have but in a house that I've all but forgotten. The walls are in the wrong place, the fireplace is in the wrong room. We no longer have that table

21

that the bowl of pears rests on. And then the whole thing is distorted around the edges. The painting folds in upon itself. It's like there's a whole world in that room, said the computer repairman boy.

While he fixed my computer as quickly as was possible with a dial-up connection, we talked. I told him about this odd life we live. (He had to ask). My husband, I said, works in a 16th century medium, oil paint. He doesn't know how to touch type (that was a much later development) let alone retrieve lost or fix corrupted files. Nor do I for that matter. I write poetry, I told him, always with pen and paper first. The repairman said he'd read Shakespeare's sonnets in high school, and he knew some pretty awesome limericks. He helped me recover a file, an essay I was writing for a poetry class. The file was called "How to Disappear: Poetic Ecstasy and the Work of Poetry." I should be more careful about how I name my files in future, said the boy. I became quite fond of him by the end of two and a half hours' labour.

*

We contrive it so that our days are as silent and as still as is allowable. Rob sits in front of his canvas for about eight hours a day. He works on a grid system, which means that he first marks off his photo at intervals using fine thread, then applies the same grid on a larger scale to the canvas. Then he spends up to two days drawing before he makes the first mark with oil paint. His painting is careful, meticulous. He might paint an area four or five inches square in a day, depending on what he's depicting. An apple might take half a day, a few plums another half a day. The drapery might be quicker or slower depending on the intricacy of the wrinkles and folds, and the way the light strikes it. He's meticulous, but paint inevitably gets on some part of his hand or clothing which then migrates to another part of the house. James Elkins, in his brilliant and off-kilter book on the alchemy of painting, titled, *What Painting Is*, says, "The last object to be stained is often the living room couch, the one place where it is possible to relax in comfort and forget the studio. When the couch is stained, the

painter has become a different creature from ordinary people, and there is no turning back." Indeed, there is no turning back. Unlike the bee who fell in love with the painting of lilacs and then gave it up, we are committed to the firm illusion of the canvas window and to the stringent scent of paint.

*

There's no turning back. Vermeer, in debt to the baker for three years worth of bread, painting sales diminshed, gave up the ghost. In a beautiful poem called, "Daily Bread," John Reibetanz notes how Vermeer's widow said that Vermeer fell into a frenzy and went in "a day or a day and a half...to being dead." But the paintings go on to feed "a hunger no daily bread can fill: for light." For us, the frenzy occurs after the American Express bill comes, at which time this poem comes in very handy — to remind of other hungers.

*

We live at the end of a cul-de-sac in the suburbs. The families on either side of us are in love with Rob's paintings and come by to admire them when he takes them outside to photograph them for his records. All summer long we receive small gifts from our neighbours. They have greenhouses that produce large cadmium red tomatoes. We receive flower bulbs, bouquets of cut flowers, handfuls of seeds. Half of the perennials in my garden come from one neighbour or another. At Easter last year, our Greek neighbour, an accountant, who lives diagonal to us, called first me and then Rob over to look at the flayed lamb he had hanging in his garage. He was preparing it for the spit in his backyard. He knows quite a bit about still life, and has seen the pictures of game that were popular in the 17th century. He saves flower seeds for me and tells me the Greek name. Every time he sees us, he gives us something. Tells us to come into his yard and pick whatever flowers Rob would like for his still life, anytime. He grows heliotrope and campion and various flowers that remind him of Greece. He also grows a long row of gladiola immediately beside

23

his house. When we do go and pick flowers he tries to press more on us. If we took every single one, I get the feeling he would be thrilled. When the other neighbours on our west side are on holidays, he picks us flowers, zucchini, raspberries, big green peppers from their yard too. He strolls over, shirt off, whisky on his breath, and swears at them in the way that you swear at people you dine with regularly, and hands off all the produce to me over the fence. He knows what would look good in a painting, and he looks for the flowers with interestingly twisted stems. He feeds us, and he feeds the paintings.

The summer after we first moved here, our Greek neighbour was the first neighbour we met. He gave us a basil plant that day. We introduced our daughter, Chloe, to him. He was overjoyed, since Chloe is a Greek name. Whenever he sees her in the front yard, and I think he'll be doing this until she's sixteen, he yells out from deep inside his garage, or where he is weeding beside the house, "Chloe, I love you, Chloe!" This always makes me feel proud and serene, and oddly giddy, none of which makes particular sense, and this maybe is what makes me always laugh out loud when I hear him, so that his loud bellowing is followed by my giddy laughter every time. He tells her that she is Greek, and I think she believes him. I heard her tell a friend once that she is part Greek, and I never bothered to correct her.

*

Whenever I hear our neighbour yell, "Chloe, I love you Chloe!" I am also reminded of our honeymoon in Italy. Rob and I were late for our train in Florence that was to take us to Venice. We'd run down the busy street that early morning, still crisp and cool, with our baggage bumping wildly behind us. We'd purchased our tickets the night before, so when we got to the station, we just frantically hopped on what we thought was our train. We'd breathed half a sigh of relief when we realized we needed to be on the train across the track, which had just begun to make slight departure-type motions. We grabbed our bags once again and threw them on the train, which started to move alarmingly quickly,

then jumped on after them. Flushed with all the excitement and minor drama, I stood at the back of the train while Rob was just inside. I was still partially outside, helping to stuff our bags into the train car, when I looked up to see a man jogging beside the train and singing in English, "I want to marry you...." He followed along with one hand on his chest, the other raised up the way an opera singer raises his hand for the long notes, for longer than I could hear him sing. We sat down at last, both of us grinning, and took big yellow apples from our bags and ate them in huge bites for our breakfast and looked out the windows at all the places going by, blissed out, saying next time, and really believing we'd be back.

Walking to our hotel in Venice, we stopped and bought more apples. We set them on the windowsill in the common room, three of them, spaced evenly, and took their picture. I remember taking the picture though I can't find the photograph. It was a picture of how we hoped things would turn out for us, so I won't describe it too well, which might spoil it, our work in progress.

*

One sentence, uttered in a certain way, starts a cascade of memory, a flooding of associations through time and space. I'm astonished at how many worlds there are within the world, at how the past lives in the present and how it sings, silent, still, in a loaf of bread, in an apple on the sill, in a handful of tomatoes passed over the fence. I'm amazed by the daubs of orange that appear on the skirt of the couch and by all the other couches through history that have had similar daubs and I'm amazed by the knotwork of gestures that hang in the air, visible and invisible, magically retrievable. It's stupefying really, how many connections can be made from looking at the objects residing on one table, in the middle of one small house. And it's true that there's no turning back.

That is how it was when, a few years ago, Rob was commissioned to paint a work for the doors of a large TV cabinet. Not for my husband the ceilings of churches or fancy altarpieces. The client wanted a picture of a vase of flowers, made to measure.

25

The painting, once executed, would need to be cut in two and then mounted on the doors of the cabinet. The client and Rob's art dealer, Doug Udell, were both sensitive that Rob might be offended by such a prospect. But he wasn't, as it seemed to remind him of something that could have taken place in the 16th century, if they had had televisions. He painted peonies, their big drunken heads, besotted clouds. There was something Jovian about them. He painted red-black cherries at the base of the vase, an offering for the flower gods. The gallery took care of the surgery, and the mounting of the painting. The framer who did the cutting, said it was a terrible moment when he'd reached the middle point and realized there would be no going back.

I like to think of it, though, this painting that was made in my basement, its colours mixed and applied in thousands of tiny strokes over a couple of weeks. I like to imagine its double life. In one it is silent and whole. It conceals, mystifies. It is the scene of nothing happening. Unless you count the stems drinking to save their lost lives, the fragrant petals slowly collapsing each onto each, the mad leaves pretending to talk to the roots, the cherries staring loud and black and deadened. In its other life, cleaved, open, winged like some strange Nike. Abiding, split, just on the other side of narrative.

Precarious

⌐

I have been taking refuge in the large glossed pages of art books lately. I have been disappearing into them as one does into oversized books, folding one's body between the sheltering covers, embraced. This exact way of disappearing is not as easy once one has grown up and all the books have shrunk. I have had Rob drag up a huge section of books from his studio shelf, with its requisite skull and dusty statuettes. The volumes are all on artists who painted still life or general books on the genre itself and are now stacked and strewn all over my study so that there is an obstacle course between the door and the red velvet chair where, most mornings, I write in my journal.

Of all my writing, the diary is the greatest disappointment. Also the point of greatest comfort. My diary is a wonderful tool, full of scraps and jottings, quotations, confessions, complaints, joys, and flights. I often write down a bare bones description of what Rob is currently painting. But mostly it is full of the drab delights of everyday. Very little gossip, no earth shattering secrets, no revelations or mysteries solved. In short, my diary is no work of art.

The most useful thing about my diary is that it reveals to me my own obsessions. Words repeat, an image is described and several pages later it recurs in a variant form. Lately, the word has been, precarious, and the images are those of things balanced on the edges of surfaces. I have taken to writing through margins. Words come to the brink and I either break them up without rules, taking them broken to the next line, or else I write stubbornly to the ends so that the letters are cramped to the point of unreadability.

It is a state we are nearly comfortable with, precariousness, and also one that we truly know very little about.

*

Setting up a still life, Rob has tied the long stems of lilies to one another with string, used twist-ties snaked around a gerbera daisy stalk to keep it upright, or curved a certain way. He's been known to affix pyramids of fruit with scotch tape. He's wedged a dime under a plum teetering at the edge of the table. Boxes are placed behind objects to bolster them, and books are slipped under plates to angle them toward the viewer. These, or similar, tricks have long been used by still life painters. How else would cracked open leather bound books poised to fall off shelves, gleaming silver knives pushed to edges, and Seville orange peels unwinding into the abyss, hold?

The still life has been prized, in part, because of the way it captures calm. A moment of tranquility that lasts. Some of the popular themes of still life though, such as Vanitas, memento mori are open contradictions of the moment of perfection. These paintings depict timepieces, skulls, snuffed candles, mirrors and are sensational reminders that whatever calm and beauty the world has bestowed on us, time will strip it all away soon enough.

One of the virtues of the genre is that we are drawn to the beauty of the objects, we sink into looking at reflections in silver and glass, marvel at the effects of light and breathe deeply the scent of painted flowers, before we give half a thought to death. We

really are quite decent at not remembering. As viewers, it is entirely possible to keep quite a distance to the little nudges a painting will give.

<p style="text-align:center">*</p>

A favourite of mine by Rob, because, truly, it is breathtaking. A yellow lily stem in a teardrop vase on a red carpeted table. The background is black and the yellow lily curves forward into the darkness, before the darkness, out over the table's edge, bright and wild and half mad.

<p style="text-align:center">*</p>

When we moved to this house in the suburbs we had a small child — she was then eighteen months old. The goal was to set things up quickly and to make them nice for her, and safe. A side effect of this, somehow, was that our cement floored, unfinished basement, which is also where Rob's studio was set up, became the very haphazard depository of various breakables. An old table dropped off in the middle of nowhere seemed the proper place to house all of the many vases that we have accumulated over the years, some bought expressly for Rob's still lifes, others were bought more with the purpose of decorating our home, though the line between these two becomes more and more blurred all the time. Still others are gifts or cast-offs. In the midst of all this glassware were a couple of broken wine glasses, the shards carefully arranged inside the remains of the goblet.

I'm reminded of this table of ours as I flip through the books that I have arranged around me so that they make a sort of semi-circular still life themselves. The books are open to various reproductions and the one that captures my eye while I write this is one by the Dutch painter, Willem Claesz. Heda titled, "Still life with Rummer, Silver Tazza, Pie, and Other Objects, 1634." Not mentioned directly in the description is the orange, its peel unwinding gracefully, daringly, almost drunkenly, over the side of the table. The silver tazza is upended, stopped from rolling off the

<p style="text-align:center">29</p>

table due to the positioning of the orange. Behind the rummer lies another on its side, the glass top broken.

What does the shattered glass speak? Are we to be reminded of desiring the material too well? Or perhaps we're to think of ourselves — fragile vessels. Everyone, I once wrote in a poem, has been, or will be, broken or shattered. It's just a matter of how broken, how shattered. In the same poem, I wrote: "Glass is death, love and time. /Because it won't last. /Because it lasts rarely. /Because light ravishes glass and / in the dark it's invisible."

Shortly after writing this poem, it became apparent that the table must be cleared, the glass must be stowed. Our daughter had taken to riding her tricycle in the basement and though she never came close to the table, I began having horrible visions of her careening into it. Each time I looked at the masses of glass crowded and stacked on this table I would shiver, and even now, just thinking about it I can hear the sound of breaking glass. And I know that somewhere, at this very instant, a glass is in the air, it has been unbalanced, it has lost its light footing, it has moved through the point of precariousness, and is now hurtling toward the hard floor. I can hear the sound of a closet door being opened and a broom and dustpan being taken up.

*

There are recurring images of the precarious in still life. One of my favourites is the glass bauble hanging from a thread, its point of origin mysterious. In Willem Kalf's "Still Life of Metal Plates with Fruit and Other Elements" the pearly glass globe holds the reflection of an unseen window. The image is reproduced in a book called, *Matters of Taste: Food and Drink in Seventeenth-Century Dutch Art and Life.* One of the authors says that the "glass ball, a reminder of Homo Bulla (man's life fragile as a soap bubble), also serves as a sombre warning." Below and off to the side of the glass bubble, along with lemons, a knife, and a dish of olives, is a chafing dish in which the viewer can see hot coals, meant, perhaps, to be a reminder of the fires of hell. Directly below the

globe though is a silver plate angled toward the viewer and a pomegranate broken open, an image associated with the Virgin Mary. If the globe were to drop it would fall on the silver platter, break, and pieces would slide down and surround the pomegranate. Heaven, the picture says, is the way to go, while reminding that hell is really not much further away.

*

Much has been written about still life as a measure of abundance and affluence. In his seminal book, *Looking at the Overlooked*, Norman Bryson says that Dutch still life painting of the seventeenth century "is a dialogue between this newly affluent society and its material possessions. It involves the reflection of wealth back to the society which produced it, a reflection that entails the expression of how the phenomenon of plenty is to be viewed and understood." This is, for me, someone living with still life, living chiefly and blessedly from the proceeds of painting sales, knock on wood, a fascinating aspect of the whole equation.

Rob has been painting full-time for fifteen years now and has been making a living, not only for himself, but for me as well (I've worked intermittently at part-time jobs and have been a student off and on, or have been the grateful recipient of the occasional writing grant) and our daughter. Obviously we have no complaints about this state of affairs. We live in the most affluent part of the world, and we live, in the grand scheme of things, very well for an artist and a poet.

In general, it's thought unbecoming for an artist to talk much about this business of making a living, or at least that's the impression I have gleaned over the years. Other artists who are not at the point of "making it" look longingly, or enviously, or angrily at the artist who has been pointed out as doing so. (Many more, of course, thankfully, find this to be an inspiration). Noses sometimes go up, backs turned. Rob has been accused of selling out, or painting to the market. When Rob and I were first dating,

we went to a lecture at the Edmonton Art Gallery. He told me that an old professor of his who'd heard that he'd been taken on at the Douglas Udell Gallery upon graduating from his BFA had ever since glared stonily at him, rushing by him with a look of disgust on his face. Could you be over-reacting I asked? And he agreed, it's possible he had been. But that night when Rob and I both were nearly bowled over by this person after being ferociously glared at all through the lecture (we'd somehow ended up sitting across the theatre from him) I decided he was in fact under-reacting.

As a commodity, the artist's work is perhaps best seen as successful, but not too successful. Some residue of the myth of the poor, starving artist yet lingers is my uneducated guess. I don't know. But it is interesting that paintings describing the affluence of a society and reflecting that back to a viewer, also contain so many objects on the brink, and even those that have tipped over. There is a part of what Bryson calls the dialogue between painter and viewer that feels to me like that catch in the back of my throat I get when I have saved something from falling off a shelf or table. It's the same sound that comes out of me when the uncertainties of living this sort of life pile up and overwhelm, as they inevitably do.

*

On more than one occasion we've gone without a cheque from any gallery for six months or more. This is sometimes due to the arrangement of exhibitions tightly scheduled so that work is being held back for long periods of time. In short, payment is erratic. We check our mailbox every day even when there isn't much hope of anything coming in. One of us trudges down to the box which is at the end of our street and then half a block over. It's a habit, a state of mind. A visible sign of the way we hang, unwinding, like a lemon peel into the abyss, waiting to be reeled up into the firm.

*

Rob reads the magazine, *Art & Auction* rather religiously. He has a great memory and often enthusiastically quotes the recent high bids on old master paintings and others, unbothered by the figures that are often in the millions. Meanwhile, he paints a multi-piece commission for a wealthy client via the gallery which later falls through for no apparent reason. Hoping to expand his market he finds a gallery in New York interested in his work. After an uplifting phone call, said gallery requests several paintings but later unceremoniously and, to me, sickeningly, mysteriously, dumps him. Soon after, another gallery phones vying for a time slot for a show. It goes on like this, more or less, the highs and the lows, the sense and the non-sense, continuously. So much of what happens is, as it is said, completely out of our hands.

*

The Polish poet Zbigniew Herbert looks at the uncertainties that the seventeenth century Dutch painters faced in an essay called "The Price of Art" in his book *Still Life with a Bridle*. Commenting on the wide range of prices that paintings would fetch, Herbert says, "We can only guess at the impact of this huge range of prices on the psychology of the painters, from reimbursement for costs of materials all the way to a sum of many years' wages for a qualified artisan." He goes on to speculate that "It might have been a stimulant for many, because it contained an element of hazard: hope for great winnings, a sudden change in life's bad luck. A chance existed that one a day a generous buyer would appear, a prince from a fairy tale like Cosimo who with one purchase would open perspectives of wealth." I think of the poor sap who was reimbursed with the cost of materials — what a slap in the face that, and I can't help but mentally move the dangling pearly glass orb in my mind, from over top of the silver platter with the pomegranate below, a little more to the left, so it hangs in greater proximity to the burning embers in the chafing dish. Because, really, that's what it must have felt like. Bloody hellish.

*

Then there's the story of Canaletto, not a still life painter, but the story's a good one. In Filippo Pedrocco's book on the Venetian artist, two letters are quoted to make the case that Canaletto was not "a person with an easy-going character." Here is Owen McSwiney writing to the Duke of Richmond, 1727: "The fellow is very difficult and keeps on changing the price everyday; and if one wants to have a picture, then one has to be careful not to make it too obvious to him as one runs the risk of losing by it, in price as well as in quality." In another letter to John Conduit: "He is a greedy and grasping man, and as he is famous people are happy to pay whatever he asks." A few pages later, the author notes that when he died, "Strangely, the inventory of his possessions reveals that he was far less well off than might have been expected, given his universally proclaimed avarice and the enormous quantity of pictures he had painted." Tellingly, at the time of his death, his possessions were said to include "a few pieces of poor quality furniture, some jewelry of little value, twenty-eight paintings that were left in his studio, and a modest wardrobe made up for the most part of old and shabby clothes and cloaks." There's something mysterious here, obviously. Things do not add up. I find this is often true in one way or another in tales of artists and the reports and assumptions of their wealth.

Referring, once again, to the Dutch painters, Herbert says, "We are surprised today that the paintings of the old masters van Eyck, Memling, Quentin Matsys — splendid progenitors of Flemish art — were relatively inexpensive, and did not arouse as much interest as one might suppose. In 1654 it was possible to purchase a portrait from the brush of Jan van Eyck at well-known dealers for 18 guldens." One sighs and groans and gasps at how little these now virtually priceless paintings could have been had.

*

But this is the way things are and one shouldn't presume to categorize oneself with the van Eycks, the underpaid geniuses, of the world. Complaint will solve nothing. Instead, I look for consolation, and this is abundant.

I find consolation in Cezanne's apples, tucked safe into the folds, the peaks and valleys, of a white cloth. There is consolation too, in a painting by Julio Larraz, called "Space Station." A dozen coffee cups are stacked, impossibly, one on top of the other, with a few saucers thrown in for good measure. Atop this leaning tower, a coffee pot. Rather than calling this work still life, the monograph on his work calls what Larraz does "still games." And there is a point when living all this precariousness becomes downright silly, impossible, a circus trick of sorts. This painting winks at me, and I wink right back.

What I have learned from attending to, and living with, those fragile things that inhabit the edges of tables is, I dearly hope, how to be poised, how to be at the ready. And part of this means, having a good supply of string and twist-ties and poster putty. I take instruction from a painting by the American painter, Audrey Flack, titled "Gambler's Cabinet." In her book, *Audrey Flack on Painting*, the reproduction of the painting is shown opposite from a photograph she worked from. In the painting, a set of dice are falling off a shelf, seemingly right out of the painting. Playing cards are sliding out of an upside down packet barely sitting on a shelf. Coins are hovering, loose. But in the photograph opposite a few of the tricks are visible. Poster putty can be seen affixed both to the Queen of Hearts and shelf. A string suspends the dice in mid-air.

Looking at this image, the urge is there, immediately present, to shoot out one's hand. To hold one's hand out. And in this, the out held hand, in this, I find the best consolation.

Calm Things

Maybe it is worth something, too, in this world of ours, to write two words at the top of a piece of paper. Calm things.

We live in the world as little as possible. When the phone rings in this quiet house, there is genuine shock. We answer, incredulous, stuttering and stumbling over too few words. I wonder what most people talk about at mealtimes. For us, the subject is usually still life. Rob says what area of his painting he's been working on. He works from a photo that I've seen before-hand, and still there is news. The grapes were much darker than he thought they would be before mixing the paint. Adjustments have to be made continually from photo to canvas. A shadow has to be deepened, a band of light refined. The calligraphy of stems needs be re-written.

At the kitchen table is also where I hear the news of the rest of the world. Rob listens to the radio, usually CBC, while he paints, and he breaks it to me gently while we eat and in between

telling me about his current subject matter — maybe an apple, a lemon, a Chinese vase.

This past year or so has been especially tiring, exhausting. We have been out of breath continually. I finished my M.A. and defended my thesis all in a year and a half. During this time a book I had written previous to this had been rejected by one publisher and later accepted by another. Rob had a show that didn't sell terrifically well. He was taken on trial by two new galleries and then let go – by one gallery on the very same day as I defended my thesis. We came home to this news after my defence and never even got to drink the champagne we'd set aside for that evening as our puffed up hearts had been stuck with pins that day and we couldn't bring ourselves to celebrate. None of these things are particularly unusual in the lives of poets and artists. But for a while the highs and lows were off balance and we found ourselves teetering about, half sunk.

But the work rights one, it calms. We sink into it and somehow our breathing aligns once again to the silent song of the still life, to the poetry in and of it all.

*

In a book on the painter Balthus, Claude Roy notes that in Japan, during the Meiji era, the term "seibutso" was formed. This translates as "calm things" and is the term used by the Japanese when talking about what we most commonly call still life. In a chapter on Balthus's wife, the painter Setsuko, Roy says that "the peaceful contemplation of calm things, has its roots deep in the Japanese past, in politeness with regard to those objects that man has fashioned, generated, humanized."

I believe in the calm of things, and also that one must come to them in politeness. The great paintings of still life that I have come to revere, that I come to with utmost politeness, are ones that must have been painted with the same approach. I think

of Morandi's rough clay jugs and pitchers and vases. The dust and muddiness of them and the clear, compassionate way that he painted them, just so. Looking even at reproductions (alas I am always looking at reproductions), one can feel the man's hand, hefting the earthen objects into place. Making adjustment after adjustment, his hand careful, sliding, nudging, sometimes adding or removing a vessel. The intimacy of these gestures! The way he has come to these things is with a direct politeness. He doesn't presume to know them — one can see that he comes to knowing through the paint, but the mystery of what they are remains.

And so it is with a painting like Juan Sanchez Cotan's "Still Life with Quince, Cabbage, Melon and Cucumber" which was the poster art for the *Spanish Still Life from Velazquez to Goya* show at the National Gallery in London in 1995. Each seed of the melon, each vein in the cabbage that hangs by a thread, and all the dimples and crags of the cucumber resting near the edge of the niche, are respectfully recorded, the colour and line and heft of them. They are arranged in their darkened niche in a parabola, the light falling on each object with utmost gentleness and a common stateliness. The air is cool where they are, and as the eye curves around the invisible crescent moon-spine, from the quince down to the cucumber, there is time for a slow and deep exhalation. Back up is the cool, quiet, discreet inhalation. It is as if the painting is training the viewer how to breathe, telling what rhythm it requires.

*

This picture of the lambent curved breath by Cotan was painted circa 1600. Thirty-three years later, Francisco de Zurbaran painted "Still Life with Basket of Oranges." To the left of the basket of oranges crowned by leaves and blossoms, is a silver plate with lemons. To the right is a plain white two-handled cup with a rose, both on another silver plate. All of these sit radiant on a dark wood table before a black background. They glow as if they are the centre of the world, and yet they are a world too, a fine and serene one.

As John Berger writes about Zurbaran's still lifes in his book *Keeping a Rendezvous*, "What is visible has been placed on the very edge of this darkness, as if somehow the visible has come through the darkness like a message." And these paintings do indeed seem to hold a message that comes to us through the darkness, through slant and sliver, and through the fires of time. Berger also says, "Zurbaran has become eloquent at the end of our century because he paints stuff — stuff one might find in a flea market — with a concentration and care that reminds us how once it may have been sacred." If we hold these things at the centre of our heart, if we look closely and attentively enough, as carefully as the painter did, then there is a visitation, the calm eloquent message. We stand in the darkness of a door frame and suddenly remember to dip a toe into the other side, into the brightness.

*

After a few years of predominantly painting still lifes with swaths of dramatic white, light-filled drapery as the background, Rob has begun painting ones with a dark background, not unlike Zurburan's or Cotan's or many other painters from the Baroque period. The current painting in the living room, on our old rickety sideboard, is of purple grapes, pears, and lemons. The pears are in a sapphire blue glass bowl, and the lemons and grapes are heaped in a tarnished silver scallop-shaped dish. They sit on a red carpet. To me they seem as sacred jewels lit from within, working against the darkness, eloquently oblivious to it, too.

It seems to me that part of what a still life does is make what is regarded commonly as un-sacred, sacred. The un-holy, holy.

We experience life in all its details. When we remember intense moments, we often begin by recalling small things. Memories of lost loved ones are often triggered when seeing and touching an object that once belonged to them or that was associated with them. A piece in the *Globe and Mail* about the survivors of the Tsunami tells of a woman whose family and home

had been wiped out was left to care for a child — the only other person left in the world to whom she was related. At the communal shelter, aid workers had at last provided her with a pot and a small stove to cook on, and though she'd been stoic to this point, here is where she broke down. Because the pot reminded her of another pot which had resided in her kitchen, now lost, and the kitchen and the pot reminded her of all the people she had cooked for, also irretrievable.

In writing of a friend who had simultaneously lost her apartment and also her lover, Susan Griffin says, "For loss is experienced through detail, when, for instance, one shops alone if before one shopped for the night's food with a lover." For loss is experienced through detail. This is when we most intensely feel the details connecting, and even that every last one is somehow connected. Anita Arbus quotes the early Christian mystic, Nicholas of Cusa, who believed that "all is in all and each is in each." And in this way, we are all connected as well. Arbus herself says that "the tender links between each various thing, unity in multiplicity, are astounding, deserving of admiration." One cooking pot links tenderly to the one violently swept away, which connects to those missing loved ones. Apples hefted at the supermarket links one to the lover who has left. We think of the still lifes of Pompeii, the pears and vessel of water on a shelf, the asparagus, bread, and fish. Someone once ate this food, and poured and took refreshment from this vessel, someone long since gone. And all the objects that we, too, use will at some point in the future belong once again to the dead.

*

The pears from the bowl in Rob's recent still life have been eaten. I cut them into quarters and peeled and cored them and placed them in a dish for our daughter. The grapes we all had a hand in eating. And the lemons were made into lemon ginger muffins. The tarnished silver dish has been returned to it's place on the shelf above the bathtub and filled again with seashells. All of the dishes, plates, vases, rugs, fabric, and various objects that

appear in Rob's still lifes also take up residence in our home. For the most part, we use them. The fruit is always eaten by us, and many of the flowers were grown in our small garden along the length of the fence. Anita Albus says that "it is only very rarely that we are able to find traces of the lives of the discreet painters of still lifes in their paintings." But I see this isn't true. For I gaze at my own small, quite ordinary life there in the pictures that Rob paints, and I can tell you the story of each one. I can see the scant weight of my entire life held in the yellow lily that I grew near the west side of the house from the bulbs given to me by a friend. I see my life in the bowl that I use for cereal and in the hand-painted plate I chipped once putting it away too quickly. Perhaps the traces are discreet, but they are nonetheless traces.

But the still life tells another story too. While the Dutch paintings of the seventeenth century mirror a society that was wealthy and that traded with certain countries, the still life of today mirrors a different economy. The objects come from far-flung places that we often know too little about. And the same is true of the fruit that is flown into our barren, sleeping winter. We try to keep all the stories straight about these objects, these things, our abundance, but they get away from us sometimes in spite of that.

Maybe it's because of this that I have always found it interesting to read articles about a still life painting whose author has painstakingly tracked down an item similar to the item depicted. In the monograph from the 2000 Chardin show are photographs of various pieces of decorated porcelain similar to those in the paintings: a Chinese porcelain ewer, a basin, a cup and saucer, and a small pot made of Japanese Imari porcelain. In her essay "Contemplating Kalf," Anne Lowenthal researches the covered Chinese porcelain bowl ringed with the memorable 'eight Taoist immortals' in Willem Kalf's most incredible "Still Life with a Nautilus Cup." A photograph of a similar piece in the Rijksmuseum is included in the appendix, as is a photo of a seventeenth-century Persian carpet like the one in the painting. In other places I have seen photos of a similar nautilus cup.

I wonder where this desire to match up the real object with the painted one comes from exactly. Is it that we imagine a connection that is yet possible to make? that our loss is somehow lessened by knowing the object still exists? is it a sort of atonement for all that we have glossed over, taken for granted? Does it speak to a slight disbelief in the still life — that more or less ordinary objects could be raised to divine status? I only know that it is oddly satisfying to see these photographs of the original object, even if it's not quite the same one. When I see these comparisons I know that I feel inexplicably comforted.

*

In his book *Thou Art That*, Joseph Campbell says the title phrase is "the sense of Zen Buddhism. You must find it in yourself. You are it." He compares this to the Christian idea that the Kingdom of Heaven is within you. Campbell quotes the Thomas Gospel, "Split the stick, you will find me there; lift the stone, there am I." The mystery is always there, in everything.

And this is where Campbell gets at what I think is also at the core of still life painting:

> Take any object, draw a ring around it, and you
> may regard it in the dimension of its mystery.
> You need not think that you know what it is, for
> you really do not know what it is, but the
> mystery of the being of your wristwatch will be
> identical with the mystery of the being of the
> universe, and of yourself as well. Any object,
> any stick, stone, plant, beast, or human being,
> can be placed this way in the centre of a circle
> of mystery, to be regarded in its dimension of
> wonder, and so made to serve as a perfectly
> proper support for meditation.

It seems to be enough most days, to draw our circles, our rings. To split the stick. It has to be. We've reached the point, too, Rob and I, (and this is a gift), where we have quit asking, why? Why keep going on with this odd and lovely and at times, invisible life? It's not that the question isn't hovering there along with us, behind us, like a crazed neon sign, blinking out of the darkness. The darkness, that's part of the answer. The mystery, the mystery is another part of the answer. Also, living with still life is a way of breathing.

Heidegger quotes Johann Herder:

> *A breath of our mouth becomes the portrait*
> *of the world, the type of our thoughts and*
> *feelings in the other's soul. On a bit of moving*
> *air depends everything human that men on earth*
> *have ever thought, willed, done, and ever will do;*
> *for we would all still be roaming in the forests if*
> *this divine breath had not blown around us, and*
> *did not hover on our lips like a magic tone.*

And perhaps it is my particular bias toward the genre of still life, but I think that when we sit long enough, quietly enough, and calmly before a fine and eloquent picture of things, it is possible to enter into that mystery, into the sweet breath of the world, magic, wondrous, divine. When we practice politeness in this contemplation, when we bow our heads, breathe deep and clear and even, we have the capacity to enter into the souls of others, to experience a delicate tracery that connects across time and distance, from one ordinary life to another.

To Lost Vessels

"It is really the fantasy of the poet who confides his written heart to a vessel, but the most lost vessel in the world, to the smallest chance."
— Helene Cixous

By whatever fate, whatever miniscule chance, it has been, for us, a year of seashells. For who is to know how or why certain gifts flow to us and in what form they may take? That a creature-vessel may be plucked from the sea in one time and place and be found in another — this seems to me to belong to the situations of dreams. The question I have been asking myself this year, how to divine the miniscule chance, how to interpret those things that occupy the realms of sea-dream?

The first to arrive were spiny, just like the one in Adriaen Coorte's painting "Still Life with Shells" (1698). In the painting, the spikes of the shell reach out of the darkness, tendrils, conducting a luminous balancing-act on table's edge. The

opening of the shell is as dark as the background. What we can see is all surface, the prickly shell at the centre of the composition, and the more lustrous shells - one brown and tight-lipped, one speckled and tonsiled, one small and red like a wild currant and the last a tiny brown cone. They are only more mysterious because of what is kept from us.

For Rob's last show, a twentieth anniversary of his showing with Douglas Udell, a catalogue was put together, for which I anonymously wrote the text. The show was called "What is Visible," taken from a piece John Berger had written on Francisco de Zurburan, and referring to Rob's Baroque influenced darkened backgrounds. Berger says, "What is visible has been placed on the very edge of this darkness, as if somehow the visible has come through the darkness like a message." I have a bad habit of asking the gods for messages, to send even infinitesimal signs, toward this odd life we lead, so abundant with ups and downs. The message I want — carry on, proceed, proceed. This is how you are to know the ebb and this is how your are to know the flow. This is how you are to exist and this is how the gift moves.

It occurs to me I have not gone unanswered this past year, after all. It occurs to me only now. Last summer, for a month, we looked after the yard, greenhouse full of tomatoes, and canary, belonging to our Greek neighbours, who returned to visit family and friends in Greece. This was a pleasure to do — their generosity ever since we moved into this cul-de-sac has been a simple and elegant force. Upon their return, we were immediately given the most incredible sage-coloured, beaded, gossamer fabric as a thank you. Then Chloe was given a handful, a trio, of spiny shells. She was thrilled, but was told there would be more — a collection that had been in the making for fifty years had been inherited from an aunt and now is brought to the unlikely, unforeseen, and possibly preordained, city of Edmonton.

And so it began. Every week or so during the summer, and then when it was colder, every few weeks, they would arrive in our house, sea-vessels, cupped in the hand of our awestruck daughter.

She began putting them on the shelves of a small glass curio-cabinet she has in her room. By mid-winter, it was brimming over, far too full. We rummaged around through Rob's glass collection and came up with a huge bowl that might have served well as a goldfish bowl. She and I carefully arrayed the shells in the bowl, layering them, finding cozy nooks for the smaller shells. We have shells that friends have brought us from Africa, Thailand, Cayman Islands and other places, but this bowl is strictly for the shells from Greece.

To receive a shell in the middle of winter while shovelling snow in our Northern, land-locked city, and seeing it placed so trustingly in the mittened hand of a seven year old, is truly a shock to the system. It seems to be an impossible act, but so it went for us all this past winter. The spring brought more shells, but, we thought, there can't be any more. We had finished our May gardening, begun the weeding of June, and the settling in and sitting down to enjoy watching things grow, when the last shell, at least I assume it's the last, was brought into the house. A nautilus.

My awe of this shell must mainly come from so many years of being in love with (merely the reproduction of) Willem Kalf's "Still Life with a Nautilus Cup, 1662." Every element in the painting displays Kalf's virtuosity, but it's the glowing orb of the nautilus — placed slightly off-centre, but balanced compositionally, by the shining lemon unwinding below and to the right on the table. Yes, the artisanry of the cup is extraordinary, but it's the shell itself that captures the imagination. I've never prodded myself as to why this is, but have just accepted that this is what the painting is about. Norman Bryson writes of the competition that went on between painters and craftsmen in Holland in the seventeenth century. He quotes Goethe on another Kalf painting as saying, "For me, at least, there is no question that should I have the choice of the golden vessels or the picture, I would choose the picture." I, too, choose the picture (who wouldn't?) with its endlessly glowing cup. Bryson points out that Kalf "paints illusions of wealth" and that he re-creates the

"dream of wealth" for Dutch collectors. True as this may be, for me, the painting is more about the dream of sipping light from the centre of a great mystery.

<p style="text-align:center">*</p>

So the fact that a nautilus shell now inhabits my daughter's cluttered room, the sole resident of a dainty glass curio cabinet, is a balm to me, a message that has whorled its way to us, over sea, through darkness, into winter and then finally revealed on the cusp of this enormous summer before which I now sit.

I've been enamoured with shells for some time, but only in a mild sort of way, in the way that an outsider becomes enamoured. Our geographical location more or less prohibits any huge study of the things themselves. Beaches do not top our vacation wish-list, not that we've travelled much at all these last ten years or so. I was once fascinated by the curiosity cabinets of the seventeenth century and gaped at the photographs and reproductions in a book on the subject by Patrick Mauries. I particularly liked the section on shells — the nautilus shell exquisitely made into a swan cup, the shell cup carried by a triton, the illustrations of cabinets chock full of shells of all sorts. And then the Arcimboldo-inspired figures made entirely of shells! Grotesque and awe-inspiring at once.

Sitting in front of the grotto at the Boboli Gardens in Florence, a lifetime ago now, I remember being both thoroughly delighted and completely overwhelmed. It wasn't long after we returned from our Italian vacation, our honeymoon, that I began working in a bookstore in a south-side shopping mall. Every so many months they had what amounted to a jumble sale put on by a local antiques society. Tables ran the length of the mall and down its corridors. They were filled, over-flowing, with old metal gas station signs, tea cups, rusted toy tractors, porcelain dolls, musty smelling books, pieces of farm equipment, stools, chairs, pails. Many of the things wouldn't have been categorized as antiques in other countries, or in Eastern Canada, I expect, but in our neck of the woods, fifty years seems old.

On my coffee break from the bookstore one Saturday, in amidst all the bric-a-brac, I spotted a fairly large shell, perched on a stack of books. Twelve dollars said the little price tag. It looked so terrible there somehow, incongruous, and not a little dusty, and I dithered. I picked it up. I put it down. I walked down the mall. I came back and picked it up again. Which is when the person selling the shell said he'd take ten. Done. When I got it home and peeled off the little price tag, of course there was a hole immediately below. Rob has painted it a couple of times now, and you'll know it for the piercing on the top side, front and centre.

*

Rob has taken some incredible photos of Chloe's nautilus shell and plans to paint the shell in a triptych, from three different angles, so that they seem to be three different objects altogether. I'm impatient, I want to see them now! But the shells will wait. When the lilacs came out this year, much stress settled upon us. The flowers were cut and ready to be photographed, and then the spring weather intervened. Huge low clouds, rain, for days. Occasionally, the sun would emerge to taunt. Our eyes were cast skyward all week. Weather forecasts consulted on a regular basis. At last, a window of opportunity presented itself before the huge cut lilacs dropped too many petals, like purple insect wings, or drooped too heavily. The photographs were taken, a painting was executed not long after and mailed to Santa Fe.

There is something calming about the shells, then. For they do wait in utmost patience, openly clandestine, emptied, in all their secret depths.

That there are many sub-genres of still life is fascinating to me. If still life has long been overlooked, then the categories within that genre are doubly so. I dream of an exhibit that is made up entirely of these sub-categories — a room devoted to fruit in baskets, a room to works depicting only bottles and vessels, and so on. Of course, one room devoted to the subject of shells. And in this room would be the etching of a cone shell by Rembrandt

— unique for being his only still life image, and for being a reverse image. Because of the etching process, the shell is shown anti-clockwise, which never occurs in nature. Rembrandt did however sign his name in reverse on the plate so that it reads correctly on the etching. Artists often look at their work in mirror image so that they can evaluate what they have done with fresh eyes. I can't help but think Rembrandt knew exactly what he was about when he declined to reverse the image of the shell.

Beside the Rembrandt, possibly one of Balthasar van der Ast's shell paintings. Van der Ast is perhaps most often mentioned for being the brother-in-law of Ambrosius Boschaert, a well-known flower painter in seventeenth-century Holland. But his other claim to fame has to do with having painted shells quite frequently. Often they rest at the foot of a luxurious bouquet, but he apparently also produced a quantity of paintings mainly depicting shells. One of his paintings is solely of shells and lizards. Frequently there are insects — butterflies and the like. I'm sure an entire essay could be written, if it hasn't been already, on the symbolism in the work of Van der Ast. On transience, the soul, insatiable yearning for light.

But there are many paintings yet to install in this imaginary exhibition of mine. Anne Vallayer-Coster, painter to the court of Marie-Antoinette, often compared to and seen to be in competition with Chardin, has a spectacular painting of shells "Still life with Seashells and Coral." The wide variety of surfaces in this painting, the vibrant and subdued colours, the daring and very memorable composition, all combine to a stunning effect. This is the painting of Someone setting out to prove what a woman can accomplish and succeeding mightily.

Who better to place beside Vallayer-Coster than Georgia O'Keeffe? "Slightly Open Clam Shell" might be an excellent choice. Much has been made of O'Keeffe's shells, in fact. Interpretations of the erotic in her flower paintings had previously evoked this response by O'Keeffe: "Well, I made you take time to look at what I saw and when you took time to really notice my

50

flower you hung all your own associations on my flower and you write about my flower as if I think and see what you think and see of the flower — and I don't." The shell paintings which O'Keeffe produced after this period, may have been a sign to critics, a call for privacy, a mode of self-preservation. Placed alongside her flowers, her skulls, the shells take on other meanings as well. But it would be equally interesting to see what they would say in a room full of other shell pictures.

For example, what would O'Keeffe's shells say beside the silver gelatin print by Edward Weston? I am thinking of "Two Shells," taken May 1927, housed in the J. Paul Getty Museum. This particular image is of two nautilus shells, one nestled in the other — each shell seems to gather a certain power and greater complexity from being connected to the other. There is a grace and tension that swells from the picture. About his shell compositions, Weston said, "It is this very combination of the physical and spiritual in a shell...which makes it such an important abstract of life." And so I can't help but enjoy thinking about "Two Shells" in the context of what O'Keeffe says with shells, and Vallayer-Coster, and Willem Kalf and Balthasar van der Ast, and Rembrandt, and others.

What would such an exhibit mean? I imagine that the mystery of the seashell would only become more intricate. Paul Valery, the French poet, has said that shells, more so than other natural objects are "more intelligible for the eye, even though more mysterious for the mind." In writing about shells as still life objects, the word 'mystery' becomes inevitable. If there is a risk in overuse, then I suppose I'll live with that. There's no point in coming up with solid theories about what the symbolism in any one painting might be, the way I see it. I'll live with the riddle of it, the mystery, then.

In fact, still lifes can be described as riddles to which the answer is always floating, since the meanings of objects shift from painting to painting. The endless possibilities that exist in terms of composition contribute to the web of possible interpretations.

Paintings refer to other paintings, the function and societal connections of objects are ever shifting, the juxtaposition of one object to another alters meanings. Meanings are lost, hidden, over-interpreted, and change through time. And then, how does one factor the artist's intentions into the interpretation of the meaning? How much weight does one give to the emblematic codes at the time of production?

What is clear is that no formulas can be established in finding meaning in still life, and in particular the meaning of shell still lifes. The answer to the riddle is variable, unfixable.

I think I've been increasingly attracted to the riddle of the still life as I'm more often thrown into the world. Cast from my room, the ocean that is thought, and from the inner depths, I am more and more often adrift on terra firma. If I begin to confuse the terms of description for land and sea, this seems right. It is possible to feel as though one floats, not altogether comfortably, between the two realms. As well, at present we are afloat between exhibitions. A little over six months ago, Rob presented his twentieth anniversary show at his Edmonton gallery. And in about four months, his show in Calgary will be mounted. We are yet afloat, aswim, miraculously it seems to me, and yes, mysteriously as well. How do we measure where we are, I wonder? By what we have carried? forged on our backs? By what lies ahead and what has gone before?

Why this past year will go down in my books as a difficult one I can hardly say. Just the sheer exhaustion of being pulled constantly out of myself. And then Chloe, for any number of reasons, has not enjoyed school, an entirely new state of being for her, so that from the moment of pulling her out of bed in the morning, to when either Rob or me picks her up after school, I feel her unhappiness curl up into the shell and bone of myself, a sad creature. At the beginning of last year, I'd started a new job, half-time hours, decent enough wages. There — many of our money problems solved, stress relieved. Lovely. But then it began at the place which I work — the mass exodus. By my one year

anniversary at this job I could count at least thirteen people, though I'm always sure I'm missing someone in the count, who had come and gone. Most of the leaving was out of serious disgruntlement over certain issues that would recur and recur. The upshot of this situation is that I would rise to second in seniority for part-timers and that I would meet and become emotionally connected to the thirteen gone and the ones that would come to replace them. I admit, while others would not be terribly affected by this (though I notice that many really are affected the same as I am), I experienced a trauma-state, for lack of a better description. I came to see, terrifyingly, the disadvantage of having worked so diligently, for so long, to heighten a poetic sensitivity to the world. I felt frayed and I felt myself often mentally cowering.

During this time, one person whose path crosses with mine rather often, in the context of speaking in a small group of which I was part, on the subject of the group of seven, said breezily, she had no interest in looking at paintings at all. They didn't move her, and she simply didn't see the point in them. I, in turn, have all too often politely listened to minute descriptions of parties, shopping excursions, television shows, and hair salon experiences. The ways in which entire modes of thinking are turned from, deliberately, voluntarily, even proudly, have necessarily become a point of interest for me this past year.

As a response to this conversation about one person's disinterest in paintings, and to countless other conversations, less overt, I have begun to learn to more consciously keep my emotional life to myself, telling others less and less about myself. To keep the clam shell only slightly open. This is quite easy to do for the most part. Rob and I have noticed that very few questions are asked of us, other than by intimate friends, about our art, our work, our existence. In some cases, I believe that this is due to a respect for our privacy, or even at times, a perceived lack of common ground. In others, bafflement, a simple boredom with the subject? I admit that I have experienced at times a terrible temptation to give up on people, on the subtle relationships we develop, and on the ever-changing riddle that encompasses our proximities to one another.

But a more interesting tack must be to go on imagining rooms of paintings, what they might say to each other, about each other. What elements previously unseen might be edged forward into the light and so be made visible? What knowledge can be gleaned from comparing one surface, truly and carefully examined, to another? What new relationships between the images might be formed? What future meanings might be sparked?

*

On one point, I was certainly wrong. The nautilus shell was not the last shell to arrive. Three more have crossed the threshold since I began writing about shells in still life. I have taken out a guide to seashells of the world from the library, and have done my best to identify them. One is said to be a "rather rare shell and highly prized by collectors." The other two, while not being described as rare, are unlike any I have seen. After imparting these last gifts, our neighbour revealed his secret to us. That all the while, the whole year, he has being working toward the last shell, an extinct specimen. And that is a gift as well — to be placed in the moment before the message arrives, waiting, from within such faith. To be allowed the grace of taking up a stance where one may believe that whatever has once been lost may yet arrive. That no matter how ridiculously small the chances are that the message will arrive, there still exists a chance.

The First Bouquet

I'm on the side of all those who have understood that sitting in a garden, dreaming, drinking a cup of coffee in the green cool of the morning, this too is an art form.

You see, we've entered the sixth summer that we have had use of this small patch of land that is our backyard. It's a small yard by most standards. In the suburbs, at the end of a cul-de-sac, one's lot is dictated by where it sits on the curve. The yard beside us is enormous, pie-shaped, and ours is the first house on the straightening of the road. This means that our backyard is wide but narrow, disappointingly narrow, and it means that we are distressingly close to the people whose lot backs onto ours by fortune of exactly the same design. We have had to adapt our garden, our selves, to this less than grand yard and we have had to absorb our limits, while believing in the limitlessness of the universe.

No sooner had I started to sink into that sublime reverie one can achieve on certain mornings, coffee cup in hand, staring deeply into the red orange pink fire of a dahlia for example, than the phone rings. The ring emanates from the house, an evil cartoon laugh. It hangs, the ring hangs in the air. I shiver and cringe. The call is from work. It seems to me, though I could be exaggerating, I'm always getting calls asking me to come in extra hours, or earlier than scheduled etc. — but I've let Rob answer. He says I'm out, which is entirely true. I am out. If anyone wants me, from here on in, they can come and find me if they dare. I shall be in the bower.

A lovely new friend recently remarked, in such a very careful and delicate tone of voice — that we had created something like a bower. I've since become truly attached to the word, saying it over in my head. The construction of the bower was necessary to block out our too-close neighbours, those huge leering pirate-eyes that a tall house in the suburbs will possess. We erected a large screen in front of our patio and have been training vines to climb up the other side and which have by now begun creeping their way over. A cedar in a good-sized clay pot blocks the view on one side. We've also planted a screen of trees and shrubs on the other side, so that walking onto the patio has the feeling of walking into an outdoor room — at least this is the effect we're striving for, still refining. Last year a fountain was added that rests in front of the screen, and helps to distract from the noise from both the people and the sounds of traffic. A friend whom I work with thought of me when she came across Tibetan bells she'd acquired at a garage sale years past, and dug them out of her shed where they'd completely rusted out. The rust has made them all the more fragile, precious, and I love that this woman knew that I'd love them. At any rate, the bells hang off our edifice, as do a bird feeder and other glittery wind chimes. I have found much solace hiding here, watching the birds first at the feeder, then perching on top of the screen. Much solace in listening to the bells, the birds, the chimes.

But the phone will ring. Many are those who pick up the phone never considering how long it takes for an artist or writer to recover from the intrusion. It is as if a dragon has flown into one's

work space, into one's very bower, and then flown off again, leaving its fire-breathing shadow hovering above, the threat impossible to expunge.

Away from the painting, the writing, the garden is our refuge — even the thought of it during our long winter is a form of escape. As I've said, it's not really much of a garden. There are weeds growing quite vigorously in amongst the flowers. The lawn is patchy in places. Perennials are in places too thick and in others too sparse. If we had it to do over, we'd move our apple trees a foot further away from the fence. Even so, we've felt what it is to live with flowers. And we do, we do live with flowers — it is something to be able to say that in this world. A clear privilege. To live flowers.

*

When I first met Rob he was winding up a series of paintings he'd done of the parrots at the Muttart Conservatory — four glass pyramids housing temperate, arid and tropical plants year round. The parrots once resided in the tropical pyramid though it's been years now since they have. He'd just switched to oil paint from acrylic and also began his next series of patio paintings. Expanses of grass, wet cement patio reflecting sky, and various flower pots were the subject of these magical paintings. After recently completing one of my twice yearly slushings out of my daughter's room, we re-jigged the things hanging on her wall so that now there was a huge expanse. Somehow I remembered that in the midst of a stack of old stretchers downstairs was the only unclaimed patio painting. A huge piece, it covers the entire wall — longer than her bed is and nearly touching the ceiling when hung. Looking at this painting again, and thinking of his Muttart Conservatory series as well, I'm reminded of how connected Rob's paintings have always been to the life of the garden. It's odd that we can forget what is most obvious, right in front of us. Those things which have carried us forward in so many ways to where we are today.

*

57

Monet once said about his garden, a little grander than ours, that "nothing in the whole world is of interest to me but my painting and my flowers." Monet's garden is such a huge draw for tourists I suppose in part because one can be immersed in another person's obsessions, in what can hold and sustain another's attention for nearly a lifetime. Walking down the lanes and gazing at the lily ponds, one can also see what it would be to live, however briefly, in a painting. To have one's attention doubly focused by experiencing the garden through the paintings. It seems to me that this would be a great gift — for attending to what is present, becomes increasingly difficult in this world. There be dragons, one could say, hovering over us, in their various shapes and forms.

It's true that the garden shares much with painting, with art. They share the big themes, it's been said — sex and death. But there is also the uncertainty, the worry, and inevitably the responsibility one develops in relation to a patch of ground or a stretch of canvas. Each flower petal, stamen, each stem and leaf, each blade of grass, is worthy of our loving attention. We are indeed responsible to the flower petal.

*

The knowledge that a still life holds, passes down, all those tangled secrets of the domestic life — I wonder if all these have yet been fully explored. I've always found the criticism that Jane Austen, in her novels, neglected to mention the Napoleonic war and other outside forces, quite an interesting one. Her well-known line, though unconnected, serves as the perfect response to this charge as far as I'm concerned. She wrote in a letter to her nephew, "the little bit (two inches wide) of ivory on which I work with so fine a Brush, as produces little effect after much labour." Carol Shields says it so well in her biography of Austen, "She is being self-deprecating here; her trust in the micro-cosmic world is securely placed. It is also a brave and original view." I somehow think it's still rather brave to put one's trust in the micro-cosmic world. Still life has also been thought of as outside history, simply domestic. But haven't we always known better? That it's all in

58

there, all of it — the all. A long time ago now, I wrote a poem about the baroque painter, Rachel Ruysch, known for her realistic — to the point of being scientific — depictions of flowers. I remember looking at many paintings from this period and counting the insects in each. (What insane amounts of time, mountains of it, I must have had then!) After a while it seemed to me that there were wars going on, and that great love scenes unfolded below the petals. There was an entire network of tiny creatures in each painting and my insight into them was extremely limited. When Rob brought home a huge bouquet of delphinium from the farmer's market a couple of weeks ago, we drank up all the variations of purple and blue, and then watched as the petals, dolphin-fins, began to accumulate on the kitchen table. One morning, Chloe screamed, as though she were being attacked. I came into the kitchen to see a rather plump green caterpillar, something out of *Alice in Wonderland*, inching its way out of the pile of petal rubble and across the table. And it was shocking. That all along, this small bright green creature had been hiding in the flowers. That we had inadvertently intruded on it, and now to us, the caterpillar was a surprising reminder of all that we don't know, can't see.

It's not surprising that we are inured to the messages of flowers, that we can look unflinching at still lifes, floral scenes with their themes, however covertly stated, of vanitas and memento mori. The vases of flowers, and the paintings depicting them, are brought into our homes in ways similar to the way the television news is brought into our home. The news of the still life is maybe rather more complex than we usually admit to ourselves. But in this age, we are experts in detachment, compartmentalism. I'm an expert myself — it's entirely possible for me to watch the evening news and then fall asleep. And I have learned, though not well enough, to divide myself from the dragons, and the piercing shrieks of the phone.

*

The garden, as one of its many lessons, teaches us the ways in which we come up against the world, the way we situate ourselves within it. It used to be in the first few years of setting up our yard, planting perennials, and then arraying annuals in pots on the patio, that we couldn't wait to show it off in full bloom, to issue invitations, when all the lilies were out, or when the poppies had their day. I have lost that impulse I once had. Now I simply want to be in it, by myself, to measure myself against whatever is glorious, short-lived. Against the clamouring beauty, and against all that is beyond understanding. Whether seen by others or no, the flowers will bloom, the petals will then fade, become paper thin, and then brown and curl and escape breathless, into a powdery dryness, into the dimension of phantoms. I used to feel neglectful when the violets had come and gone, when the mock plum bloomed and no one had glimpsed these besides us. But for those who know the garden, I believe the presence of all that has flowered is felt after the blooms have left us. They are seen in the mind's eye, everything all at once, by miracle of the imagination.

While I write, mid-summer, there is a fresh bouquet of lilies, pink, white, orange, yellow, on the kitchen table, all from our garden. Meanwhile Rob is in his basement studio painting the spring plum blossoms. He had cut a bough and placed it in a narrow vase with my Chinese robe as a backdrop. The robe is fuchsia with dragons embroidered liberally upon it. I save it to wear on those summer mornings devoted solely to the drinking of coffee, reading the newspaper, and thinking. I will wait until he brings the painting upstairs, finished, to assuage my curiosity as to how faintly the embroidery will be delineated. However, I will know they are there, for I have worn them certain mornings, a fuchsia skin. Thus have I become reconciled to dragons.

Rob took many photos of the plum blossoms, and so he is able much later in the season, to bring them back to life in the form of a painting. The practice, though technologically separate, is really not so different from what took place in Holland in the 17th century. Painters of floral still lifes produced sketches of flowers so that they could incorporate them into paintings of bouquets that

could not actually have existed. Flowers that bloomed in different seasons could all be viewed together in this way. If one looks closely, one can see recurrences. Artists even borrowed flowers from each other — so that the very same bloom appears in the work of two artists. When the price of a desired specimen was too high, artists would go to a garden and sketch a likeness. What is it that's so interesting about seeing these impossible bouquets, that the Dutch artists would go to such lengths to capture these flowers in paint? Is it that there is something that speaks to us in this ability to capture multiple time-lines, to tap into and focus our attention on the elasticity of time?

Many of the artists, Rachel Ruysch for example, were known and lauded for their scientific, botanical interests in the details that they represented. But what other desires are there behind such a painstaking process? What are the relationships between the garden and still life that have yet to be sussed out?

I only know that when I get home from work of an evening, Chloe will be asleep, and we sneak out to sit in the garden and are transformed, returned somehow to our selves. We sip a slow gin and tonic, and talk softly, privately, and wait for the sun to slide down into itself. Then I light the candles, ones on the table and up on the deck and then the ones we've placed by our small Buddha statue that sits at the foot of one of the apple trees. And then we just sit. We watch the flowers and plant life sober up, change, transform. I look around in the darkening and address the plants in my head. One of us will say, oh, don't the cherries (which have by now begun to turn red) look radiant in this light? and look how tall the bush is now. We planted it six years ago, a small specimen, and now it towers above the fence. The tiger lilies clumped behind the apple tree really do become tigers as they glow and flicker in the candle light.

Rob will talk about the flowers he happens to be painting, about some nuance or curve of the petal that he really hadn't taken in until he was immersed in the painting of them. And the flowers in the dark begin to seem like poems I might have once written,

61

and I begin to feel that I might in fact be a writer after all, no matter that it seems next to impossible to get to the page so many days.

A couple of weeks ago a friend Rob has known since his early twenties was in town and came over after his own kids fell asleep in their grandparents' home, and ours was reluctantly in bed. We three sat in the garden, candles lit, until a wind came up in huge gusts, and blew out all the little flames. Then we moved indoors where Rob brought up all his paintings from his studio into our living room that he's been saving up for his next show in a couple of months from now so our friend could see them. Rob propped them up all around the room, against the coffee table, the stair railing, the buffet, and our friend wandered among them, crouching down now and then. He's the sort of person who isn't afraid of a bit of silence, the sort of friend with whom it's a relief to simply be. When Rob painted the tropical parrot cages this friend asked him to wear a white t-shirt that he later reclaimed to wear himself. The technique Rob used then to get the muted, misty effect was to finish the work by spattering it, and the t-shirt ended up in a similar state, an indication of the work of painting, the gestures, and also the mud of it.

This particular night, in our living room, which felt electric, wildly lit, after being enveloped in black in the yard, it was as though our friend was in a garden leaning in to take a closer look at a flower, to breathe the scent more closely. Most of the flowers in the paintings are from our garden, a fact which impressed our friend. One of the favourites among those who have seen this latest batch has been a painting of mixed blooms, plucked from the garden as a child might pick a bouquet for her mother. They're simply not flowers a florist would ever assemble, and yet there is something so charming about them, so unguarded. They send us back, to what? childhood? to a moment when the gift of flowers is taken in joy and awe and with a child's delight? But then to paint this kind of bouquet is something too. To know that it too deserves the attention a painter may bestow.

Well. There is also a bouquet of sweet peas, though really, I must remind myself, it is a painting of a bouquet of sweet peas. Is it only me, or do sweet peas fill everyone with an enormous feeling of innocence? Which is to say that those pangs of guilt we are apt to feel in a day are absent. But also, a most pleasant sleepiness. I remember my mother helping me pick a bouquet, the first bouquet. She wanted me to have them in my room so I could go to sleep and also awaken to the smell. It was something her father had done for her. It was the first bouquet I had all to myself, in my own room, on my own dresser. I can't remember the scent falling asleep, but I do remember awaking, breathing, small I must have been, lying in bed for so long refusing to open my eyes, breathing. Where am I, I breathed.

*

By now there are two more flower arrangements in our kitchen that are past their prime. Rob photographed them a few days ago and now we watch them decompose, become less like themselves. Watching the snapdragons lean on the delphinium in the one vase, and then the mixed bouquet — the dahlias, bee's balm, daisies, geraniums, Canterbury bells, lilies — abruptly drop so many petals, I'm reminded how artificial this is, this writing, how out of time. For I've been writing for weeks and weeks, while I've tried to make it seem as though I'm capturing a smaller span. In making art, there is the desire to slow time, to capture the multiplicity, the intricacy, the fullness of existence. But I've also wanted to get at both the way in which our consciousness is so easily split, and also the way that we can attend to the multiple registers from a place of wholeness.

There is so much happening in the garden, right this very second. The cherries are deepening, plumping, the apples are busy weighing down their branches. A young sparrow learns to fly, and the cat, waits, lazily enough. The Russian sage so late this year, begins to come on — big fat bees hang on it, and the water fountains flow. The goldfish in the giant Chinese pot swim and

the vines continue to climb, search, cling. I haven't even begun to understand all the secrets that gardens will hold, particularly this inconsequential and yet so sustaining bit of a bower. Artist's gardens have often been poured over, photographed, recreated, theorized. I've noticed that they're made to stand for various things in the biographies of artists, sometimes seen as a key to the text of how to create. And maybe gardening is a way of organizing the mind for that particular flight. One thinks of Frida Kahlo's courtyard, with its bright colours, the stone work, the terra cotta pots filled with over-confined, misshapen trees, the bed where she spent so much time visible through a doorway, elevated. Even I can't help but see her art, her mind, reflected in the photographs of her garden.

It has to be more difficult than this though, more complicated, more elusive, and certainly more tangled. Strangely fascinating to me are the maps I have sometimes seen in obscure books on still life bouquets from 17th century Holland. These resemble un-started paint-by-numbers. Below the ghost picture is a chart of numbers and names so that the viewer could match these names to the flowers depicted in that particular painting, usually reproduced on the opposite page. The ascribed meanings of the flowers could then be brought together after consulting emblem books of the time, and an entire message could be retrieved. For example, roses and lilies were symbols of the Virgin Mary, while the violet, according to Paul Taylor in his book on Dutch flower painting, was an image of "timidity and humility." The peony represented "voluptuousness" while the sunflower could be seen as "the devout soul following God." As Taylor points out though, it wasn't mandatory to interpret flowers in this way, and that "probably rather few people actually did." No matter how often we're told that red roses are for love, and yellow for friendship, and so on, the fact remains, that we somehow know better.

I can understand Georgia O'Keeffe's frustration at the interpretation of her paintings as solely sexual, erotic. Of course they're that, obviously they're that. Yet there are reasons that we call upon flowers, still, to speak for us — even though the elaborate

historical and symbolic meanings assigned to them have mostly drifted from them. They take on whatever we ask — consolation, passion, jubilation. But there's more, right?

I'm brought back to thinking about the tulip, in all of this. In reading about the tulip frenzy, or if you prefer, mania, that occurred in the 17th century, I'm intrigued by the language used to describe the most vied for blooms. These blooms are — 'broken,' and have 'feathered' or 'flamed' petals. They are 'breaks.' Although many experiments were made at the time to discover the cause of the breaks, it was only in the 1920s that the mystery was solved. According to Anna Pavord in her book *The Tulip*, the breaks were caused by a virus spread by aphids. Aphids or no, looking at a broken tulip, the breaks, the mystery remains.

Do we not sense that these flaming, feathered petals take us elsewhere, and are, in fact, otherworldly? Are not all petals evidence of a rent in the fabric of the universe? Here are we, humble garden-dwellers — at the split — the threshold. Look long enough at a petal, be it dahlia, rose, sunflower, sweet pea — and be transported. Peer into other realms!

*

No, I don't know what our little bower will say about my art, or Rob's. But when there are a few days in a row, free of intrusions, I begin to really hear the bells, the tearing of petals, I begin to feel that the "other side" is nearer than I often do think. I pick up a dahlia petal, spilled, from the yellow centre of a finished flower, I rub it between thumb and forefinger, I rub it on my cheek and chin, perhaps it is my imagination gone mad, or that I have spent too little time, frenzied, drinking fast and greedy, the colours of the modest and miraculous blooms in my garden this summer. But when I'm living flowers, quick, uninterrupted, or when I find them arriving again in the paintings, I am brought back to the moment, breathing, where am I where am I where am I.

65

Of Coffee Pots, Teacups, Asparagus and the Like

If I keep coming back to the gift, it is because I find it the proper place to dwell. Long before I came to Lewis Hyde's book on the gift, I opened up a fortune cookie to read "the more you give, the more you shall have." I'm the sort of person that possesses an utterly childish faith in these small strips of paper, and that one particular fortune keeps cropping up. Writing, creating art, one finds oneself in a constant state of giving and receiving. I think I knew this instinctively rather than with any deep thought surrounding the idea, when I was working on editing my first book. There I was, very pregnant with our daughter Chloe, thrilled that there indeed would be a first book, and terrified about what the process of editing would entail. What it was — an incredible exchange for which I will always be grateful. At some point, my wonderful editor, this woman whom I'd never met, had never seen even a photograph of, emailed me that she saw traces in my poetry — I must have read the Hyde book on the gift. I had not. Of course I ran out directly and ordered myself a copy.

It was difficult to take in really. But I felt that I had been given a splendidly profound gift then, in that small mentioning of a book supposed to be in common. It is the moment of the gift that must be remembered (and yet at times I have forgotten), carried, and most importantly, moved, given, carried forth. Susan Griffin has talked about this as well in her book, *The Eros of Everyday Life*. "Whether we know it or not," she says, "we exist because we exchange, because we move the gift. And the knowledge of this is as crucial to the condition of the soul as its practice is to the body." Crucial to the condition of the soul. Yes. A resounding and holy, yes.

In *Journal of a Solitude* May Sarton says that "the gift turned inward, unable to be given, becomes a heavy burden, even sometimes a kind of poison. It is as though the flow of life were backed up." If we don't keep the gift moving, it pools, becomes stagnant, putrid, there is no room to receive. Hyde envisions a sort of "begging bowl" that the artist creates within and "to which the gift is drawn." In exchange for his poetry, Pablo Nerudo is quoted as saying "I have attempted to give something resiny, earthlike, and fragrant…" Thinking about that begging bowl, and Neruda's earthy, fragrant gifts, I am somehow reminded of a morning this past spring.

A robin had made her nest in our front tree. We watched her build it at a very odd angle, so that it faced outwards, rather more than is usual. When the eggs appeared, they seemed as bright blue jewels recently plucked from a golden saintly statue, the eyes of heaven, and were angled toward us so that we could see them perfectly, and our daughter only needed to stand on her tiptoes and crane her neck a little to look right inside the nest. Every day she would make a point of looking at the nest — sometimes, shockingly, the mother would be in it, looking comfortably regal on her tipped, dangling throne. It was difficult to tell where the bird stopped and the nest began, stare as one might. But one morning, Rob looked out to see a huge crow ravaging the nest. Seconds later the eggs had been guzzled, the mother robin sent on her way, the nest sprawled on the ground. What could we do once the tears

were shed, but pick it up, lightly put the pieces of broken shell within, and bring it inside? Chloe placed it in a glass display dome, meant for flowers, but perfectly encasing the nest.

We've begun a nest collection, then, without really trying. We've received. My sister saved a nest for me that had fallen out a tree of hers last year. Soon after, two more fell out of trees, having served their task. One is an exquisite little thing, made primarily of hair, mostly blonde, like mine. In fact, it must be mine. It blew from out of the fragrant, spicy, blossom-laden mock orange bushes in the front yard. No matter that I've read it's terribly bad luck to find your own hair in a bird's nest. I just can't see it that way. Instead, in this exchange of hair and home, I glimpse the condition of a soul — mine.

Whenever I have seen the reproductions of Van Gogh's birds' nest paintings I have imagined that he must have painted them as a gift for someone. This, I think, is not the case, though we can still feel the paintings as gifts. The nest, seen as emblematic of 'rebirth' or 'resurrection' was likely even more than this to Van Gogh. In *L'Oiseau*, a book Van Gogh was fond of, Michelet says, the nest "owes everything to art, to skill, to calculation" and that the nest becomes the bird's "very person, his form, and his immediate effort — I would say his suffering."

In my mind the nest and the begging bowl meld together, the giving and receiving difficult to disentangle. Though, this much is clear — Van Gogh took the gift of these nests that he received from nature and later stacked in his cupboard, thirty or so of them, and sent them back into the world in the form of paint — earthy, muddy, mossy colours, dark and whirling, fragrant and sublime.

Those paintings of still life that seem to be excursions, off-shoots, detours — paintings that could almost (though not really at all) be seen to be details of larger pictures — these are intriguing to me. In browsing through Rob's huge and heavy stack of books on still life, there were a few images that I had to keep coming back to,

as though they were calling. As it turns out, they all have in common that they were presented as gifts. One of these was Manet's 'Bunch of Asparagus,' 1880. Manet painted other 'small' paintings of a single subject — one lemon on a plate, four mandarin oranges, three apples, a melon, and so on. But the asparagus stands out because of its companion piece, a picture of a single spear of asparagus. The story is that Manet upon finding out that Charles Ephrussi, the buyer of the 'Bunch,' had paid more than was asked for, repaid the wildly generous act, by sending along the painting of an additional spear. What a smile this gift must have provoked! And still astonishing, for such acts must always be rare.

I know a little something of how one feels when receiving the gift of a painting made expressly by the artist for its recipient. Among several of the paintings that have been tenderly wrought for me alone, is a dragon fruit in a deep bowl, fuchsia in colour against a backdrop of Titian-red fabric. The bowl is so deep that only the top of the fruit is apparent. It emerges, winds up, out of this mysterious well, an unknown thing to most who have seen the painting. Maybe the singing I feel inside, looking at this painting, comes from being in on the secret. But there is something else too. Beautiful and whole in itself, bare and simple and yet radiant with an inner light that seems to emanate from the bowl, this gift reminds me to carry on with putting forward these things I can write, however small or sidelong they may seem. To develop a generosity from deep within so that it may erupt, thereby enlightening the soul, and even infect the souls of others with a similar generosity.

It is all there too in the stalk of asparagus painting, that exchange, that really says, let's have this for the day's goal — to give more than to receive. Which is a difficult thing to accomplish, in truth. For our part, the gifts we receive are at times overwhelming. A handmade bowl from a co-worker, an ornamental metal sun, Tibetan bells, shells from all over the world, African masks, wine, always wine, a basket of apples from a neighbour, endless cucumbers all summer long from another, peaches hand-picked

from British Columbia. Then there are the kind words sent in emails, encouraging and real, complimenting Rob's paintings, my poems. What to do with our riches, but to attempt to send them out again in the form of our work? Words and paint. To empty out the begging bowl. The abundance.

And there are more examples. 'White Cup and Saucer' by Henri Fantin-Latour was painted as a gift for Ruth Edwards, as a thank you for letting him stay at her home from July to October of 1864. The white cup resides in that perfect state, neither empty nor yet filled, conjuring such a still, calm energy. It seems to me there is a force surrounding this image, an electricity. A perfect conversation is about to take place, hovering over this teacup. Soon the spoon will be employed in lovely gestures. Anything might happen because of the teacup.

And then there is the painting Manet gave to Berthe Morisot, a well-known artist herself, and sometime model for Manet. She is often depicted in these paintings with a fan, and in one with a bouquet of violets — and in this painted gift both are there along with a folded note, the writing only hinted at. Ahh, so many secrets in this painting — the fan folded rather than unfurled, the indecipherable note, the posy of violets traditionally thought to symbolize virtuousness and humility and the colour sometimes stood for fidelity. Is it an agreement, an acknowledgement, an appreciation, a thank you, a good-bye of sorts? We only know that the image has a certain sparkle, a charming intimacy about it. We only know that the gift is moving...

Somewhat more known are the circumstances surrounding Van Gogh's paintings of painted sprigs of flowering almond to both his sister and another similar canvas to his brother Theo and sister-in-law Johanna for above their bed. On a spring trip to the south of France, hoping for a warmth and sunshine conducive to work in nature, he instead arrived to cold and a drape of snow that reminded him of Japanese landscapes. The two studies he completed there of almond branches, in bloom in spite of the

bracing cold, are cited by critics as being indicative of Van Gogh's optimism at the time. In a letter to Van Gogh, Theo writes that Vincent's nephew "is particularly fascinated by the blossoming tree that hangs above our bed." One sprig is propped awkwardly, ungainly, in a simple clear glass. The unassuming and yet defiant blooms have all the appearance of having just reached out, opened. The paint is alive with them, sparking into existence, their warmth meeting the cold, invigorating, pressing out of the canvas. It's no wonder that a young boy would be captivated with the sensation looking at the blooms must provoke.

But these are all examples of gifts that have been received. I must recount the story that Balthus tells in his memoir. He had arranged to have his good friend Giacometti present a painting of a coffeepot he'd rendered, to a café waiter. He later finds that this painting resides in the estate of Giacometti upon his passing. Balthus, pained, muses on this: "Could that mean he never gave the painting to the waiter? I believe in Giacometti's honesty, so I doubt that this could be true. I did regret that the person I gave the painting to never received it. I wanted to extend to him a real gesture of friendship to express a sort of fraternal connection. I wanted to do it discreetly so that he wouldn't have to thank me or feel uncomfortable in my presence." He goes on to express "great sadness and disappointment." He says, "Sometimes a hand extended, the traces one wants to leave behind, sink into the abyss. Like sparks that blaze up and are extinguished." One can feel the huge anguish this failure to connect, this possible refusal, this omission, caused even many years later. The wondering, the unknown particulars, all contribute to the sinking that one feels oneself in reading the description. It is the gift turned back on itself that extinguishes so thoroughly and abruptly and sadly, those sparks that glorify, feed, infuse and nurture and that are in short, so entirely, so intensely, essential to the soul.

How well we artists and writers know the chances of our work sinking into the abyss! And yet how grateful we are to be able to make these marks, to live a life that risks blooming in the bracing cold, that can offer tender furled messages, indecipherable traces.

A life that has allowed us to sink into the knowledge of the real and difficult abundance, while merely sitting before a white teacup on a table. It is something, as well, to pay attention to the traces of these fine eruptions of gratitude that escape into paint. For we have much yet to learn about how souls connect, let alone about the intricate properties of teacups, their simple gleaming.

Spring, Again

We've decided this fall to buy a painting, someone else's work. We're not entirely sure whose work and it will be a small painting in accordance with our budget. Our idea at one time had been to buy a small piece once a year or so, and to form an art collection in that manner. But things got away from us, bills piled up, the stress of an always uncertain income played upon us and we relinquished the pact we had made. The urge came back though, as a reaction to something that happened a couple of weeks ago.

The phone rang and it was the Calgary gallery people to whom Rob had just sent the last six works for his show which was to be in two weeks. You can tell by the timelines I've just given that this happened recently. Normally I like to wait before writing about something, let time gather around an event or image, see what sticks to it. Not this time. I need to be here, so I don't forget the details, so I'm not tempted to make light. I don't want anything to adhere.

The people at this gallery usually phone when they receive paintings for a show and make soothing and congratulatory sounds. I always have heartily agreed with the bit in Virginia Woolf's diary when she says, one depends so much upon praise. Rob spends months alone in the basement with very little feedback except from close friends, loved ones, and so I imagine, after checking the call display, he picked up the phone rather cheerily. But there was news, unhappy news, they began to break it to him gently, distraught, stunned, there had been tears evidently, he could hear it in their voices. Two of the three boxes arrived with holes, with the same proportion as a forklift might have, straight through. Four of the paintings ruined, gashed, mutilated.

Every single person that we've told this story to has gaped and gasped. The first time I told the story I broke down, wrecked, I had to get off the phone. I couldn't stop those wracking sobs. I only remember crying a few times like this in my life. I felt myself breaking down — and later I knew that whoever first came up with the phrase 'nervous breakdown' had likely had one herself. I felt myself turn to rubble, or as a clay bowl melting back into earth, soft and formless. I was not robust enough to withstand this latest misfortune. I crumbled.

Rob, on the other hand, was stoic. I marvelled at him, I wept some more. I wept for the paintings themselves, yes, I admit I wept for our lost income, and I wept for the whole summer of small sacrifices. Finding just one more thing to do with Chloe so Rob could have an extra hour or two to paint, getting up early, groggy, before she woke up, ignoring friends, ignoring phone calls, always somehow or another juggling time — the date of the show, September 30, loomed before us all summer. Rob and I hardly saw each other. I'd keep Chloe amused and occupied and then pass her off to him and go to work myself at the library. I hardly wrote a word all summer, but that was okay too. I'd get my time. At one point, jokingly, I had said to him, you need to do something so I can have more material for my essays. I can live without material like this.

The day after we found out about the damage, I ran an errand to the mall. Leaving, backing slowly out, inching until I had a line of visibility beyond the huge truck beside me, my car was hit, backed into, rapidly, scraping. Okay. It's only a car, no one hurt, just paint scraped. Good. I knew there would be a third thing so I had Rob go and collect the mail that afternoon, and sure enough there was my poetry manuscript, rejected once again, my *Red Velvet Forest*. The reader felt it read as 'unfinished.' And maybe I'm the deluded poet-type, but I have to say he missed the point. Of course it's unfinished, it all is. Well. These are small things, these last two occurrences, the rejection, the scrape, that made up our three. Our three bad things.

The photos came via email later, and the paintings arrived back home themselves a couple of days ago — relatives who had driven down to Calgary brought them back for us after the opening of the show. Right now I have on my desk photos splayed, of the details of the punctures, slashes. These along with the diet coke cans, the messy piles of books, and myriad of sticky note reminders, give the place the feeling of a crime scene investigator's office. I can't stop looking, squinting really, blinking away any dampness, at the damaged bits, as if this might make them go away. I'm not yet so hardened as the cops on television.

A couple of friends who we told of the damage said promptly, "Please tell me the one with the plum blossoms and kimono survived." But yes, the plum blossoms and kimono painting, though the least damaged of the four, exhibits a six inch scar, a gaping wound. The one complaint Rob has made through all of this is, that the kimono, the embroidery, had taken so very long to paint. And I can see him down there for days making so many small brushstrokes, him, leaning in closer and closer, trying to get the effect of the embroidery without in fact resorting to embroidery.

Norman Bryson says that "all of the artefacts surrounding the body share this fate of imminent reversion to debris." And maybe that's why I was struck down by the news of

the kimono painting, my kimono, the one that becomes a skin to me those warm mornings in summer, being cut open. It had become perverse. The still life has as part of its subtext, this seemingly magical ability to outwit fate, to thwart that imminent reversion to debris. The objects live on in paintings beyond their normal shelf life. These damaged paintings of ours brought home the fact that the paintings, too, are merely objects. They too are subject to ruin, decay, damage, negligence.

The crying done and over, it was time to problem solve. Rob phoned his Montreal and Edmonton galleries who were incredibly sympathetic and arranged to send some unsold pieces to fill out the ravaged Calgary show. So the show did, as they say, go on, and it was beautiful, if not the exact combination of pieces that Rob had meticulously planned, taking into account dimensions, colours, subject matter. Chloe wore a black Chinese embroidered dress to the show — dragons for good luck and peacocks for happiness, the woman in the store told us. And it was a good day — Rob did have luck in selling his paintings, enough of them so that we can go on, which really is all we want to do.

So, now, days later, I ought to be filled with relief, but no I can't allow myself. I do want to but maybe it will always be impossible now. And maybe this is better than the infernal highs and lows. I'm in that state of — what? — feeling anything might happen at any moment. It's an odd time, I can't help thinking, to be an artist. Some days I feel like we need to be saved but we're not going to be saved, I'm not even sure from what. And anyways, if anyone is going to be saved in this world, surely it ought to be those millions living in poverty, near and far. Those who are facing real life and death situations, real struggles — some are in our own family, some are our friends. As for us, we can muddle through well enough. So it seems. But it is the lot of the artist in the West that the work will eventually be seen against this greater backdrop, just as the Dutch still life paintings of the seventeenth century are viewed against the larger political landscape. The abundance and affluence depicted is always going to be measured against the social stratifications and the perceived impulses within those layers.

What stories will these paintings that Rob has made, lived, crawled inside, tell about his life, ours together, about the larger world? Biographers tend to seek out the cracks — madness, the dramatic defining moment, disaster, illicit love affairs, rebellion. I tend to agree with Balthus, who upon being asked for more biographical information for a catalogue produced for his retrospective exhibit, replied "Start this way: Balthus is a painter about whom nothing is known. Now we may look at his paintings." It would be best if whomever might pick up these essays of mine, later finding themselves before the paintings, could indeed forget everything I said.

So, yes, we are going to buy a small painting. I don't want to know anything about the artist. I want to learn to look in this way again, knowing nothing. I want to live this way, too. Savouring all that I can't know, leaning toward the ineffable, into the scent of blossoms, looking, squinting, feeling. And maybe I just want to be the one to save a painting or two. To guard somehow against any imminent reversion to debris.

I've stopped crying over the plum blossom painting, at least I think I have. I ponder instead the words of the poet Loy Ching Yuen. He says, "The fragrance of blossoms soon passes; /the ripeness of fruit is gone in a twinkling." And then, "In moments of darkness and pain /remember all is cyclical. /Sit quietly behind your wooden door: /Spring will come again." So it has, and so it will. And we sit quietly, quietly, closing our eyes from time to time, trying to see into the cracks the world might reveal any moment, surrounded by our dragons and peacocks, fortunate and happy.

Acknowledgements

This book wouldn't have existed but for the incredible support both Rob and myself have received as artists over these many years now. Supreme thanks goes to all those people who have ever bought a painting of Rob's or one of my books. Douglas Udell spotted Rob's talent at a group show way back in 1985 and has been a strong believer in his work ever since. Thanks to all of Rob's galleries: The Douglas Udell Gallery in Edmonton and Vancouver, the Wallace Galleries in Calgary and the Shayne Gallery in Montreal.

While writing these essays I was supported by the Alberta Foundation for the Arts, for which I am immensely grateful.

The thought that I could write a collection of essays on this subject came out of a graduate course led by Greg Hollingshead. Many thanks to him for all his nuanced and insightful comments, and thanks also to all the students in that class.

Thanks to all my friends in writing: Bert Almon, Kimmy Beach, Nina Berkhout, Olga Costopoulos, Michael McCarthy, Iman Mersal, Michael Penny and Karen Press.

Thanks to the editors of the following magazines who published several of these pieces and whose encouraging comments really meant the world: *Artichoke*, *Cezanne's Carrot*, *Event*, *Existere* and *Prairie Schooner*. "Still, Dead, Silent" was the winner of a Glenna Luschei Prairie Schooner Award.

To Rob and Chloe, who inspire me daily. To all my family, without whom this writing life would be so much more treacherous!

My gratitude for three very dear friends grows with every year I know them. To Lee Elliott, Barb Langhorst, and Annette Schouten Woudstra — I raise my champagne glass — for your wisdom, kindness, divine clarity and humour. Thank you for all your many gifts my dears.

Thank you to Dawn kresan and Palimpsest Press for daring to make beautiful books in general and this one in particular.

Books Consulted

I read many books on art during the writing of these essays. I'm especially grateful for the presence of the following works on still life in particular: *Still Life with a Bridle* by Zbigniew Herbert (Ecco Press, 1991), *Shimmering in a Transformed Light: Writing the Still Life* by Rosemary Lloyd (Cornell UP, 2005), *The Object as Subject: Studies in the Interpretation of Still Life*, ed. by Anne W. Lowenthal (Princeton UP, 1996), *Still Life with Oysters and Lemon* by Mark Doty (Beacon, 2001), *Objects on a Table: Harmonious Disarray in Art and Literature* by Guy Davenport (Counterpoint, 1998), *Looking at the Overlooked* by Norman Bryson (Harvard, 1990).

About the Author

Shawna Lemay is the author of five books of poetry, *All the God-Sized Fruit* (McGill-Queen's University Press), *Against Paradise* (McClelland & Stewart), *Still* (self-published), *Blue Feast* (NeWest Press), and the forthcoming *Red Velvet Forest* (The Muses' Company). She has a B.A. in Honors English and an M.A. in English from the University of Alberta. *All the God-Sized Fruit* won both the Gerald Lampert Memorial Award and the Stephan G. Stephansson Award. Her blog is Capacious Hold-All. She lives in Edmonton with Robert Lemay, a visual artist, and their daughter Chloe.